KU-522-028

Art Now

Victor Vasarely

SPIES.|W

£2.50

-4. JUN. 1974

Victor Vasarely

WERNER SPIES

16 COLOUR PLATES, 53 MONOCHROME PLATES

THAMES AND HUDSON · LONDON

Translated from German by Leonard Mins

General Editor: Werner Spies

*First published in Great Britain in 1971 by
Thames and Hudson Ltd, London*

Printed in West Germany

ISBN 0 500 22012 3

Malevich, one of the pioneers of geometrical abstraction, called the black square on a white background – the "zero form" – the naked, unframed icon of his time. It was a spiritual form, a silence beyond the world of objects, transformed into an image and filled with faith. Vasarely's "plastic unity" *(Unité plastique¹)*, likewise a simplified structure, whose life is the simultaneity of two kinds of information, is an almost unideological form, free of the senses. I say "almost" because in Vasarely too the plastic unity is not based freely on a Constructivist or optical model, but is derived from an objectively experienced world. In Vasarely the objective relationship, and even the Constructivist character that brought this objectivity forward and suppressed it, became more and more evanescent until finally the nonobjective, Constructivist structures were likewise replaced by a simple cell, the plastic unity (page 64). The large, interconnected plastic form that characterizes Constructivist-geometrical composition gives way to a new compositional principle: the serially variable assemblage of our aesthetic perceptual image. Malevich's "icon," the aesthetic and philosophical end product of a process of abstraction, becomes the building stone of an entirely new plastic composition.

Vasarely's system of the plastic unity is the most progressive instance of a form of design which is based on both Seurat and Malevich and in which intellectual history and the history of form are combined. Vasarely is a man of synthesis.² Two kinds of elements have entered into his system: Impressionism and Cubism constitute his world, which might be designated the *iconography of optical aggressiveness.* This world lies between the *art of perception,* which makes a theme out of the visibility of an object, the intensity of its appearance in the field of perception, and the *art of apperception,* which aims at bringing about an understanding over and above pure perception.³ The visual confusion *(aporia)* of the viewer goes back, essentially, to Analytical Cubism.⁴ Even there the spatial interpretation (as convex or concave) of a visual element is a very difficult problem. However, it remains subordinated to the reading of the image. Thus, for example, in Josef Albers' *Structural Constellations* this open system finally becomes a line pattern that produces complete spatial aporia and never lets the viewer resolve the ambiguity.⁵ This experience on the part of the viewer is a known fact in the theory of perception.⁶ Merleau-Ponty describes this reaction to an ambivalent perceptual figure and points out that it is impossible to apply learning or habit to such phenomena.⁷

Vasarely's discovery of the plastic unity, which is an irreducible, pictural molecule, seems at first sight to have an analogue in the "point" of the Pointillist method. The Neoimpressionists' point is closer to the plastic unity than Malevich's square is. In its total identity of iconography and form, the square means itself and is, as Josef Albers says, a "factual fact."⁸ Seurat's point, however, is "actual fact"; it brings about a mixing in the eye of the viewer. The plastic unity lies between these two extremes, that is, the square as an expressive form in Malevich and Seurat's blending of particles. The plastic unity can be compared to a clearly recognizable network; the optical impression that Vasarely regulates according to various programs in his works always includes perception of this network. The matter might be formulated as follows: the optical fusion takes place on a level of perception that leaves the conflict between particular form and Gestalt open.

Vasarely's irreducible element is completely standardized. It is not only formally but also thematically the germ of the picture. The optical stimulus it possesses in each case (in connection with other and differing plastic unities, it is reinforced or diminished) constitutes not only the perception of the viewer but also contains an apperception, which takes the place of the iconographic interpretation. The comprehension (increasing and decreasing optical stimulation) is conditioned by the perception. If the concept of iconography entails the idea of "reading," interpretation (this still applies for the works of Cubism, and of informal and of geometrical abstraction), the concept of reading does not contribute any clarification in the latest works of Vasarely, which are produced on serial principles.⁹ We observe in every case that in reading apperception gradually replaces per-

5

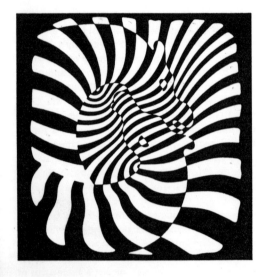

ception, overcomes it, and excludes it in the next encounter with the work. In Vasarely's case every meeting with the work is a new event; perception, with its variant of a gradual optical aggressiveness, can never be done away with by a return to recollection, to the *déjà vu;* the reading always comes back to the original starting point (page 47).

In the last few years Vasarely has been engaged for the most part in working out a plastic alphabet.[10] The works of this period, whether paintings, graphics, reliefs, or sculptures, affect the viewer by virtue of their additive structure (pages 49, 66, 70, 71). Separate formal compartments unite to form a more or less easily understandable whole. Vasarely worked out these additive elements in the course of decades of experiment with graphic problems. He introduced the color factor of the latest works as a component of the composition based on the plastic unities. Sometimes, in these serially developed works (pages 43, 65), the color is the main compositional force within a plastic unity, as a simultaneous contrast.[11] Hence, the color factor first appears essentially in Vasarely after the period in which the compositional elements were embodied as a system of individual forms.[12] Color is the presupposition of the plastic unity, and first makes it usable. The two-tone color chord achieved by permutation with another plastic unity creates, out of the "blind" monochromic plastic unity, a new unity that is brought into existence by the color "interaction." We designate a plastic unity as blind when its background and form are of the same color. But the plastic unity never occurs blindly, that is, with backgrounds and forms identical in color and hue. The minimum differential is a half-step within the same scale.[13] This does not necessarily lead to highly contrasting color. In many works what is decisive is the nuance, the range of hues, that Vasarely presents within the domain of a single color. With the addition of an unchanging tone in another color to such a gradation of hue, Vasarely is able to create differentiated systems of optical irritation[14] (page 67). In most cases a new color, seen simultaneously, appears when a contrast in form is attained at the same time[15] (page 65).

Vasarely's world of form, following principles that are based by preference on mathematical and scientific analogies and imitate cybernetic processes in calculating the solution, was developed in four separate phases. In the first, Vasarely became acquainted with the doctrines of the Bauhaus; in the second phase, along with his work as a commercial artist, he elaborated models for a system of graphic theory of his own; in the third, he worked out Surrealist themes; and in the fourth he made his own contribution to geometrical abstraction.[16]

The first three phases, which served as stages of development for Vasarely's work, which is based on the plastic unity, are little known.[17] As a rule, the literature ignores the question of Vasarely's independent development. His objective works, although rich in anticipations and in fact always pointing toward his later work, are almost systematically excluded from consideration: as if the Vasarely of the plastic unity were in hopeless contradiction to the Vasarely of the forms with reduced objectiveness. Vasarely, in his own account of himself, makes many references to his youth and the period preceding the eruption of his personal artistic expression.[18] But he too confines himself to brief references. A glance at the four phases mentioned above should precede any account of Vasarely's personal aesthetic and ideological phase, which begins with the works made up of single bits of information. The Constructivist phase of geometrical abstraction begins after World War II. Apart from the works themselves, which can be adduced in each case, we have Vasarely's own testimony, which is very clear and perspicacious. We will take this testimony into consideration whenever it is relevant to our study of a particular work.[19] The break after World War II, which we put after the third, Surrealist phase, is supported by Vasarely's statement: "It was not until 1947 that the 'abstract' was revealed to me really and truly, when I realized that pure form-color was able to signify the world." The "form-color" formula foreshadows the new aspect of the work, the plastic unity. Color is effective only in communication with form, namely, a graphically circumscribed area, and form and color become synonymous.

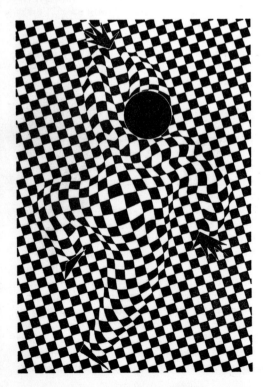

6

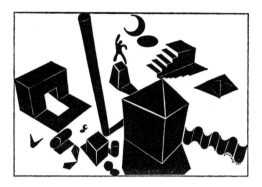

Victor Vasarely was born April 9, 1908, in Pécs, Hungary.[20] Even as a child he showed a remarkably developed talent: the drawings of the seven-year-old amazed people. After secondary school, Vasarely attended the Podolini-Volkmann Academy. The education he received there was conventionally academic, in keeping with his gift for naturalistic, exact representation. While going to school, Vasarely worked as a bookkeeper. His father had had to abandon the idea of sending him abroad to learn the hotel business. Vasarely designed advertising posters. One poster he did was for the Budapest branch of a Schweinfurt ball-bearing factory. The ball bearing was drawn with photographic accuracy. One morning, while Vasarely was in the office of the manager of the Budapest branch, the manager received another artist. The reaction of the colleague to Vasarely's sketches was: an actual photograph would be just as good. Vasarely learned only two years later that the colleague who had analyzed and criticized his work so sharply was Alexander Bortnyik.

After that Alexander Bortnyik became Vasarely's real teacher.[21] Vasarely joined the Mühely, known as the Budapest Bauhaus, which Bortnyik had founded in 1928. At the outset Bortnyik, in collaboration with Farkas Molnar, had wished to set up a cultural center to correspond to the Bauhaus, with which they had both become acquainted during a stay in Weimar between 1922 and 1924. But the material conditions for such a project were lacking. Bortnyik had to be content with setting up a school of the graphic arts.[22] The time that Vasarely spent in Bortnyik's studio was not without conflicts. Vasarely was a virtuoso draftsman, most reluctant to accept the teachings of his master. He rebelled against the reduction of mediums that Bortnyik was striving for. To use his own words, he felt that these exercises were a loss of his substance as a draftsman.

The reference to the Budapest Bauhaus is further elucidated by some facts that have recently come to light. In a letter from Bortnyik to Vasarely, he gives a sketch of his own development, his stay in Weimar, and his teaching in Budapest.[22] The most important point in this is Bortnyik's statement that he was less attracted by the subjectivism of Klee and Kandinsky than by the Constructivist and functionalist ideas that had come to the Bauhaus via De Stijl. Bortnyik was especially interested in Moholy-Nagy, who formed a sort of link between the two trends.[23] Thus, Bortnyik's teaching brought Vasarely in contact with material studies and other problems of the Bauhaus preparatory class. He became acquainted with painting techniques and, using Wilhelm Ostwald's color theory, prepared color scales that led to white and to black.

Although Vasarely had an inner feeling of resistance to Bortnyik's teaching, because it seemed to hinder him in his characteristic talent – graphics and drafting skill – he still instinctively felt the significance of that teaching. The clash between simplicity and complexity into which he was urged by training and natural bent was to become a constituent element of his work. In point of fact, that clash can still be traced today; his returning to a simple plastic unity in order to use it in provoking a complicated perceptual stimulus is, as it were, the symbolic form of the contradiction he experienced in Bortnyik's studio between individual and society.

In 1930 Vasarely moved to Paris after having to give up his plan of going to Berlin. In the Paris that he got to know, he could discover no trace of the Bauhaus.[24] Now free from the bonds and obligations of the Hungarian Mühely, he returned to his natural virtuosity. It is true that in his graphics studies, which he carried on along with his profession as a poster artist, he combined this graphic verve with a Constructivist method derived from the Bauhaus.

A work like *Etude bleue* (page 23) shows how Vasarely combines a search for structural relationships among geometrical superposed grids and concentric circles with an anthropomorphic representation. The right side of the study shows that Vasarely was interested very early in moiré effects. These networks of lines in superposed layers foreshadow the period of the *Photographisms* (pages 8, 9, 44) and the *Pictures in Depth* (pages 38, 39). It is true that *Etude bleue*, with its almost didactic confrontation of organic and geometrical form, still has something of the element of pathos. The cosmic viewpoint that finds expression in this iconography was later to come still more strongly to the

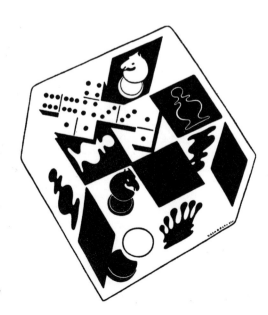

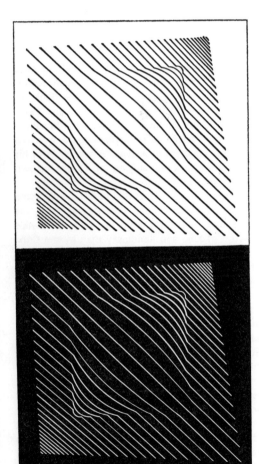

foreground.[25] In later works Vasarely overcame the confrontation and was able to adapt the linear network to embrace organic forms.

Among Vasarely's most amazing and least-known works are the studies of materials, drawn in *trompe-l'oeil*.[26] They belong among the drawings that Vasarely made as examples of graphics for a drawing school he wanted to open (page 28). They are reminiscent of work originating in Josef Albers' preparatory course at Dessau. Vasarely treated such problems as "apparent and true three-dimensionality" exclusively as problems in the plane. Although the studies of textures and materials remind us of Albers and Schlemmer (the drawings for the Triadic Ballet),[27] these early works already exhibit an obsession that is characteristic of Vasarely. The motifs that keep recurring (chess pieces, harlequins, dice, spheres) are later found in many of Vasarely's works. Very important for the future was his concern with two problems. The first one (page 28 left) relates to structural effects, further pursuing the experiments begun in the above-mentioned *Etude bleue*. In the study of wood, however, Vasarely departs from the strict geometrical solution of the *Etude bleue* and approaches a technique that is closer to his later oil paintings and the organic *Photographisms*. The second problem confronts us in the *Material Study* (page 28 right), in which several phenomena pointing to the future occur. Here for the first time numerical units are taken up, especially in the compartments of the framing dominoes. These areas are archetypes of the plastic unity that Vasarely was to develop twenty years later. By the variation in the number of pips, an optical composition is formed in which the eye must content itself with recording various bits of information. This is the first indication that perception can take the place of iconography. Bone and dice bring additional information into play, which again brings into question the purely optical pieces of information given by the dominoes; or at least it brings them into a very precarious position. It is not merely a formal relationship that is involved. The interaction of bone and dice brings about a Surrealistic stimulus. This, as stimulus to the structure of the picture, keeps recurring in Vasarely's work. Second, the relationship between the various large round forms (knobs and spheres) points to the later possibility of quadrupling a plastic unity and multiplying it by sixteen (page 63). Third, the three dice lying within the picture space bring up the motif of perspective representation, which here can still be grasped with objective clarity, but later, when the objective reference became unclear or was dropped, was to lead to a spatial and formal ambivalence (pages 37, 69): many forms in the works of the geometric-abstract phase are perceptually unclear, insoluble images. We do not know whether they are surfaces parallel to the picture plane or surfaces projecting in space and seen in perspective. Here we have a statement of Vasarely's concerning the "shift forms."[28]

Among the decisive works of the thirties are, along with the graphic patterns, which were to constitute an inventory of the possibilities of black and white, a number of advertising posters. *Mitin* (page 24 right) presents the convex space illusion that Vasarely was to vary in many of his works. The *Harlequin* (page 6 bottom) gives a new treatment of this problem, while presenting it in an essentially more complicated version. Simple posterlike clarity (in the *Mitin* the convex illusion is still reinforced by conventional shadows) disappears from this work. The problem is to bring out clearly the contour, volumes, and motion of a form against a background that already presents an overpowering optical aggressiveness. The means that Vasarely uses are enlargement and distortion of the checker pattern. A background whose strong optical stimulus already engages perception fully is confronted by a uniform but distorted optical stimulus. It is hard to comprehend the figure against the background; it resists any immediate apperception, even though there is no question of an optical dead end.

In the thirties Vasarely lived in almost complete isolation. He had no interest in "cultural art," which he attacked so vigorously later in his writings.[29] The influences we can trace in his work at this period go back to study of the poster designs of Cassandre and Francis Bernard. The clear, puristic

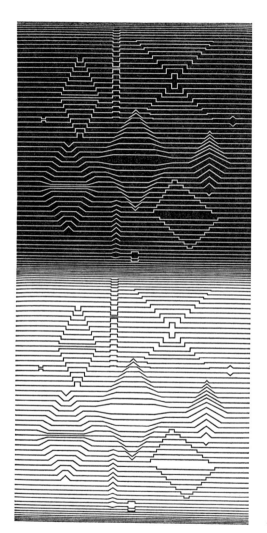

sweep in Cassandre's posters and Bernard's composition, working with tones, became important for him. It was only in 1939, when Vasarely came to grips more firmly with the art of his time, that he discovered in a comic strip that Cassandre's puristic composition had been influenced by such artists as Ozenfant and Le Corbusier.

Vasarely had been trained as a commercial artist in Bortnyik's school. During his first years in Paris he compensated for the work he did for an advertising firm to earn a living by a system of free graphics, methodically organized to create a graphic alphabet (pages 6, 7, 25–28). By the end of the thirties he began to devote more and more of his time to such free graphic activity. His purpose was no longer to take these studies as models for a school of graphic arts. He treated them increasingly as independent creations. These works–zebras, harlequins, and checkerboards–were exhibited for the first time by Denise René in 1944.[30] It was Vasarely's first show. Among the works was one in which Vasarely investigates a variety of forms–gateways, truncated pyramids, stairs, cylinders, cubes, crescents (page 7 top). Shadows are cast by light coming from a different direction for each object. The objects themselves are of the same pictural substance as the shadows, a deep black. This study is extremely important in showing how Vasarely produces a shadow that in each case fills out the object in question. The illumination is form-producing; the result is not "object + shadow" but a totality formed by the object and the shadow. This new form is not always explicable in every single case, that is, we draw a distinction between the object taken as three-dimensional and the two-dimensional shadow that is cast. But the fact that the shadows fall in different directions destroys the objective logic of the work. We can disregard the cause-effect system and conceive of individual forms as a totality in which the shift from the two-dimensional to the three-dimensional aspect vanishes. Our interest is not so much in the problems of perspective contained in this work, nor in the changes in an object when it is projected on a surface at this angle or that, but rather in the fact that systematic complication of a form by combining it with another gives rise to a new structure. If we take away the white lines that Vasarely drew in to isolate the separate areas, we have a series of individual forms which he was later to apply in his geometrical abstractions (pages 11 top, 13). The objective origin of these forms is evident, and yet the objective reference retreats more and more, in the course of a long development, and "free" form prevails. We become aware of the movement of one and the same shape forward and back. This makes the study in question an important starting point for an inventory of the basic optical forms that during the fifties take the place of iconography. The unity of form and shadow helps us to a better, less formalistic approach to a number of Vasarely's works. The opposition between work that is conceived purely optically and work that is spiritually embodied can be traced down to the famous picture *Homage to Malevich* (page 37). Here too we still fluctuate between a spatial and a surface interpretation; our inclination is to see a rhombus as a square drawn in perspective. We have difficulty in escaping from the perspective convention in this representation.[31] On the basis of such ambiguity Vasarely erects the system of his positive and negative solutions: within a system of nonobjective geometrical form, our memory, our experience, and our cultural reflexes continue to play a part. It was their very derivation from an objective world, their reference to a region we have left behind, that gave these works their impulsive character and indicated their stylistic situation.

In 1945 Vasarely, in a second show, presented a series of oil paintings. Jacques Prévert wrote an introduction for it, describing it with the synthetic word *imaginoires* (from *imagination* and *noir*, "black"). André Breton was enthusiastic over the show: at last, he said, the Surrealist painter was born. Surrealist influence in the works is evident. It is to be seen in the juxtaposition of incongruous objects which are brought into the picture with equal weight (page 29 left), in the manner of Dali's paranoiac-critical method.[32] Surrealist influence can be seen in the painting technique as well. Vasarely saw the Max Ernst exhibition at Denise René's gallery in 1945, and it is true that he imitated Ernst's *frottages*. But while Ernst's technique was to rub over a sheet of paper laid on a

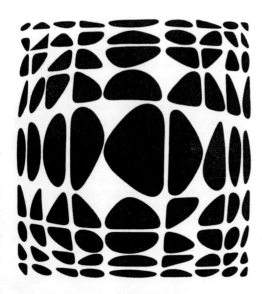

textured surface, Vasarely simulated the effect with minutely detailed paintwork (page 29 right). He put a ground on the canvas with a brush and applied the fine network of his drawing with a tube, giving these pictures a relief-like surface. From the technical point of view, this way of working goes back to decorations that Vasarely had done years previously, applying patterns in relief to chocolate boxes and bonbonnières. In this he achieved a twofold effect. Seen from above, these decorations looked colorful and brilliant; seen from the side, they looked flat. The double effect of a surface, here taken in a decorative sense, became another archetypal pictural form. In the interaction between frontal and profile views, we recognize an important model of unfixed perception, a process in which the eye is subjected to a constant fluctuation of stimuli. This alternating perception produces a kinetic impression. Vasarely's kinetic experiments, which have never involved mechanical movement of the picture, go back to these changeable bonbonnières.[33] He himself says: "Beyond purely optical movement and other movements brought about by the viewer's changing his position in front of the picture in relief, I personally have never considered any other mechanical movement than what is produced on film with the aid of a camera."[34]

In these relief-like pictures, which are only an episode in his work, Vasarely attacks formal problems, which he here combines with a thematic mode of painting. He tries to link the technical automatic mechanisms that were essentially akin to his nature with an objective, symbol-creating statement. The contrast of white and black, on which the graphic system lives, takes on a significance—when carried over into painting—which, according to Vasarely, means the end of war and of the terror of war. During this very brief objective phase together with influences from Surrealist painting and the representation of surface textures reminiscent of Max Ernst's *frottages*, we find Cubist and Expressionist influences and figure representations that go back to Kupka's *plans par couleurs* ("planes by means of colors").

Vasarely is very critical of this period today. He calls it a mistake, and is right in saying so when he compares these works with the aesthetic solutions he arrived at in 1947 in Belle Isle and in 1948 in Gordes; for these tortured, often styleless works do not satisfy. However, they are essential for an understanding of Vasarely. They show that, even in a period of the most direct influences, Vasarely's own obsession comes through and that, when he made the decisive step forward to making standardized parts, he helped in the birth of a prefigured, more or less conscious principle of composition.

From 1947 on, Vasarely began a systematic stylization of his objective experiences. The essence of his objectivity had now altered. Formerly it had consisted in contrasts of form (page 28 left) and associated Surrealist motifs; now Vasarely turned more and more to cosmic themes. The Denfert period coincided with the Belle Isle and Gordes periods, although it reaches back to the thirties. At that time Vasarely was fascinated by the innumerable hairline cracks that formed patterns on the tiled walls of the passages of the subway transfer station of Denfert-Rochereau. He examined minutely their half-geometric, half-irregular mazes, whose structural disintegration inspired Vasarely to pattern drawings. But now for the first time, he transformed this mixture of precision and automatic compositions into unique works which suggest classical landscapes; for it was exclusively as such that Vasarely interpreted these fine networks (pages 32, 33). In this limitation there are two aspects. One is the almost monomaniac automatic reaction of seeing nothing but a landscape on Leonardo's wall;[35] the second is a devaluation of the objective, arising out of the fact that in continual reference back to the same objective model it becomes neutral. The cracks in the tiles, interpreted as landscapes, are an iconographic minimum; the constant repetition of the same association, cracks/landscape, destroys its representational content.

The Belle Isle period too has a natural experience as its starting point: the pebbles on the beach, the rippled sand, the waves, and the horizon. In the Denfert period Vasarely started from an encounter in which random cracks and eidetic interpretation still combined to suggest the objective (landscape).

1

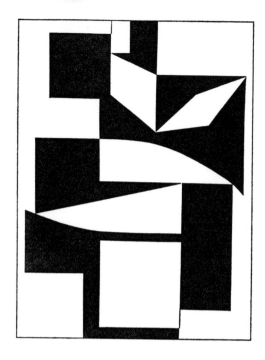

Belle Isle is the period of the first abstraction: Vasarely now reduces the simplest natural shapes, pebbles and waves, to geometrical forms. These keep their connection with the natural phenomenon but now signify pebble, sun, wave, and cloud all in one. The "mental aspect of art" still has the upper hand; the egg shape has to express the "ocean feeling." Vasarely loves to bring these forms together into landscapes in which sun and clouds become intensified heavenly phenomena (page 35). In the figure on page 34 he combines individual forms into related cosmic units. By enlarging the elements toward the center Vasarely achieves a convex effect that can also signify the intensification of a form confined to a flat surface (page 10), anticipating the works composed of plastic unities. Examination of these works shows that the basic forms arrived at are used less and less to evoke natural associations. In their half-free and half-serial order, they prepare for the cosmic works of later years.

The Gordes period (pages 11 top, 30, 31), named after the hill town in Provence where Vasarely stayed in 1948, signifies a third variant of a freer plastic commitment. Here geometry appears most strongly as a theme. Here too the harmony between objective motif and intellectual structural order is important, along with a solution of the problem of the drafting of stereometric bodies. Vasarely, starting from an observation of nature, came up against the question of how a cube should appear within a surface. Rather than the solution of a central perspective, he preferred the axonometric solution, which represents the cube, without any foreshortening of the principal surfaces, as a combination of squares and rhombuses. This mode of representation was suggested to Vasarely by a 1931 poster of Cassandre. The latter had designed an axonometrically drawn double cube for the printing firm of Deberny et Peignot. There was a D on the upper face of the lower cube and a P on the underside of the second cube above it. The effect of this poster was remarkable, just because the extremely difficult interpretation of the spatial situation of the two square sides marked with the D and P aroused the interest of the viewer. In the meantime Vasarely had discovered this axonometric representation in works of Kupka as well; in Gordes, however, it had become a visual experience for him. It did not become the nonobjective raw material for serial works that he was to employ from 1965 on in his *Homage to the Hexagon;* the axonometrically formed structures were symbols for window openings, sometimes seen black from the outside and sometimes white, from the inside, in glittering light. Above all, the version seen from within, a bright square on a dark background, was a symbolically understood form; it showed the view of the prisoner outward.

During these years the linking of form and surroundings was of particular interest to Vasarely. It involved an examination of easel painting as such, of the possibility of filling the canvas to the border, of letting the picture strike against the frame with undiminished concentration. Magnelli's solutions (interchangeability of form and background, background and form) failed to satisfy Vasarely, since these forms were confined to the center of the canvas. He aimed at a picture that was completely and uniformly filled. He found it in works by Otto Freundlich.

It is impossible to speak of these pictures from Gordes in cool, analytical words. Even if we take them as backward-looking prophets of Vasarely's concrete optical iconography, we trace in them, behind the forms, a philosophical fluctuation between sensory observation of nature and "cold abstraction." Intellectual-sentimental parallels between forms and ideas appear, such as Herbin had wished to standardize in his "plastic alphabet." Vasarely meditated on the content of a new set of subjects for art: "It is no longer a matter of deriving inspiration from things or beings, present or recalled, but of inventing worlds which have hitherto eluded investigation by the senses: the worlds of biochemistry, of waves, of magnetic fields, of relativity. But this esoteric world of the sciences is inaccessible for most of us. Therefore, plastic structures had to be created which were so many sensory equivalents, which could be assimilated by intuition. The new configurations will soon become charged with meanings, and will contribute indirectly to the enrichment of knowledge."[36]

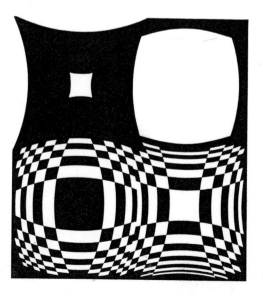

1

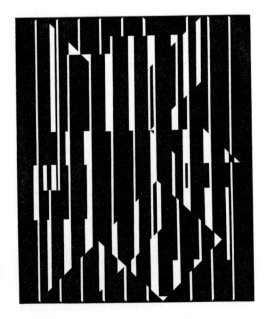

Most of the works dating from the early fifties belong to this series originated at Gordes. A realm beyond the perception/apperception mechanism was to be represented. The objectivity of the earlier works, along with their constant formal problems (positive/negative, moiré patterns, composition with interchangeable parts, compositions of continuous, unbroken lines), is transmuted into the domains of the universal and the microscopic. The title of the picture suffices to establish a structural order as part of a rationalized, comprehended world (pages 42, 45). In recent years these relationships to poetical or intellectual actualities have become increasingly rare. This is related to the fact that Vasarely's goal, which at first had not been systematically approached, has become more and more clearly defined. If we look at the latest works—the wood reliefs, the silk-screen prints up to *Permutations*, or the almost monochrome compositions—we see that Vasarely, after a very rich baroque phase, has found his authentic starting point, the plastic unity. In the early works the development of a pattern was always subordinated to the generalizing act of the *painter;* larger forms, in their relationship to the whole, forced the picture into tense motion (page 15).

The geometrical forms developed in Gordes were of importance, along with the *Photographisms* (page 9), for the kinetic *Pictures in Depth* (pages 38, 39) and for the *Black-and-White* period (pages 12, 13). The latter goes back to the *Pictures in Depth*, which consist of two or more Plexiglas plates, spatially separated from one another. The next step was that Vasarely used direct illumination to transfer to a sensitive plate the complementary-supplementary background drawings that he had made on separate Plexiglas plates. In the photograph, the compositions, which had previously been separate in space, merged. However, the spatial separation could still be traced (pages 11 bottom, 17). Vasarely worked these photographs over with gouache or India ink, and transferred the result to canvas with oil paints. The use of photography gave Vasarely new capabilities. He produced both the positive form, in which the black graphic system stands out against the white background, and the negative form, white on black. Since the solutions were also mirror images, the differences between the two versions of a visual idea were considerable (page 13). Gradually Vasarely came to master this semitechnical, semifree manner of composition to such an extent that he was able to make the compositions formed from two or more superposed Plexiglas plates without having to resort to these intermediate phases. The dynamics produced by these contrasting solutions of a single problem gave further scope to Vasarely's kinetic art, which aimed, not at a kinetics of reality but at a kinetics of perception pulled this way and that between the contrasts. The aggressive bits of information presented by the picture keep the eye constantly on the alert. The picture attacks the eye ceaselessly. What Vasarely calls "kinetic effects" are basically the aggressive elements of a picture, which prevent a static comprehension.

The decisive intellectual achievement of Vasarely consists in the creation of a plastic unity and the resultant mobile system. As we have suggested, the plastic unity was implicit in Vasarely's work from the outset. It is made up of the automatic repetition of individual motifs; it is the final goal of a development extending over many years. But the plastic unity is not only a formally organized pictural alphabet; it is, as has been said, the result of an ideological procedure.[37] The basis of this is that the artist, in the sense of genius, has nothing more to look for in our time: "The title of 'artist' is to be had free."[38] This victory over the artist, one of Vasarely's fundamental utopias, is tied up with the conviction that art today has reached the period of reproducibility. In Vasarely's case, in fact, this much-discussed problem appears in a new light. It is not only that the plastic unity, as an individual element that is produced mechanically, is always reproducible, but the iconography of optical aggressiveness would be repeatable as well: the optical stimuli it communicates are independent of the artist's own brushwork and other factors constituting the original. Vasarely has constructed his work so consistently on this basis of reproducibility, or more exactly "identical production," that one cannot help asking whether what many mourn as a loss of authenticity is not really a gain in authenticity.[39]

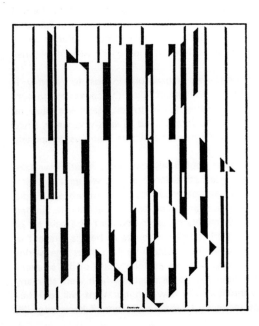

1

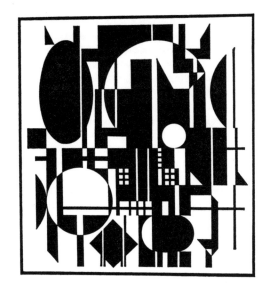

The plastic unity was mentioned on the first page of this book. It is a great temptation to interpret Vasarely's work in relation to this, and to regard it as a function of the plastic unity. A slight qualification is necessary. Even though in recent years the works based on the plastic unity are in the foreground, it should not be forgotten that there are also many works that are hardly reconcilable with it. The plastic unity is predominant as the alphabet of the *Planetary Folklore* and of the works that play with color scales, evoking colorful smoke instead of the motley hues of the *Planetary Folklore*. In the last three years Vasarely has elaborated another system, based on the hexagon. He calls these works *Homage to the Hexagon*. Some of these works present squares drawn in perspective (page 59); others show them axonometrically (page 69). In both cases the system is a hybrid one as compared with the uncomplicated square form of the plastic unity. Yet it is not possible to fill a rectangular canvas completely with hexagons. There are border areas that can no longer be divided up into hexagons. In order to even out these irregularities, which disturb Vasarely's system of the completely filled picture surface, he likes to surround these works with coffered borders that cast shadows. The geometrical austerity of the composition is guaranteed only if the viewer does not notice this trick. There is an equilibrium between the systematic organization and the free sweep of light or dark zones. Strictly speaking, these works are fresh evidence of the impulsive creativity which is in constant conflict with the systematic thinking of Vasarely.

There is still another series of works that falls outside the system of plastic unities. Ideas derived from the *Photographisms* are treated in two-colored concentric circles, with gradual increases and decreases in the proportions of the scales of the two colors. *Vonal-I* (page 68) is a different solution of the same sort. It is based on a system of square bands resembling a series of boxes placed inside each other. This was prefigured in such serially produced works as *Arcturus II* (page 61), in which Vasarely did not alter a hue within the same square strip. Thus, we can distinguish two fundamental tendencies which keep recurring in Vasarely's work: one is "corpuscular" (the plastic unity is an outstanding example of this), and the other is "undulatory," like the works of the type of *Arcturus II* that have just been mentioned.

In terms of the plastic unity, all these new experiments go beyond the limits of the system. But this is only the case if the present system of the plastic unity is regarded as a final plastic alphabet. It would be premature to do so. The plastic unity, in its binary, quadratic form, derives from Vasarely's reflections on architecture, on modular structure. If the architects could propose other basic forms that were likewise modular, he would grasp at them; for his works are a pictural activity taken in analogy with architecture. (In Vasarely's words, the new title of the artist is *le plasticien*, "the plastician.") Conceivably, Buckminster Fuller's spheres built up out of triangles were the stimulus for the new honeycomb "unit" in the *Homage to the Hexagon*.

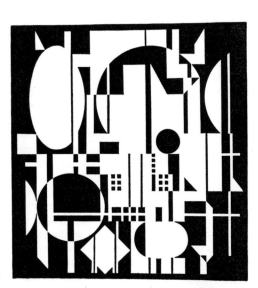

We have repeatedly observed the repetition of identical basic forms (checkerboard patterns, rhombuses, dice) in Vasarely's early works. Their "corpuscular" character is striking. They are structures made up of parts that can easily be isolated. The additional factor is the kinetically conceived interchange of plus forms and minus forms, of white and black, and their uniform proliferation in every direction without creating any preponderant form. In such situations we have before us precursors of the plastic unity. Vasarely studied these early works with especial interest in 1952 and 1953. As he says, he found himself in a blind alley at that time. Even the *Homage to Malevich* (page 37), in which one and the same form signifies a rhombus and a square cast out into space, did not advance him any further. Then he discovered, among sketches for textile patterns that he had made in 1932 for a mill in Lyons, sheets on which he had drawn nothing but squares and their more or less sharp transitions into rhombuses, thirteen times horizontally and fifteen vertically. Another sheet had a study of black circles on a white background, each cut off on a different side. The distance between the individual black portions was great enough for the white to act as a graphic element organizing the sheet. By means of the continual interaction between white and black, an imaginary

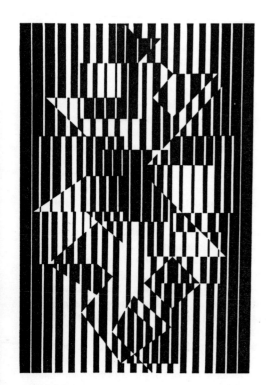

system of lines is formed in the viewer's eye; he constantly sees the black form on its imaginary bright square. That was the first clear-cut form of plastic unity, a binary unit made up of a white background and a black form. These early works led Vasarely to the works of the *Black-and-White* period. *Tlinko* (1955; page 54) and *Betelgeuse* (1957; page 46) are beginnings, in which he not only uses the system white/black but brings together elements of the early textile-design sketches into major systematic works. By means of certain devices a system which seems at first glance to be slack, tautological, is converted into a sensory demonstration: in some places the white is denser; the form grows at the expense of the background. In other places Vasarely employs the converse process in order to bring the black out more strongly. Here the circle was not shorn off but introduced in another form, as an ellipse in spatial perspective. In his *Cassiopeia* (1957; page 42) Vasarely shows how, by using these simple basic shapes, cut-off circles on a white ground, organized forms can be created by an aggregation of individual elements of this kind.

In 1959 Vasarely had developed the plastic unity system to such an extent that he was able to put collages together from single elements.[40] The idea was a very simple one; round, oval, square, rhomboid, or triangular shapes are cut out of a colored square. Form and background are independent of one another. The red oval cut out of the red square can be set into a green square out of which a green oval has been punched. The green oval, in turn, can be set into the red square. Vasarely had his discovery patented on March 2, 1959. At that time he was working with the following colors and forms: three reds, three greens, three blues, two purples, two yellows, black, white, and gray; three circles of different sizes, two squares standing on an angle, two different rhombuses, two sets of two parallel rods, one triangle, two circles shorn differently, six ellipses, three of different sizes inclined to the left and three of different sizes inclined to the right. At first these plastic unities were still punched out of the highly photosensitive Montevrain paper; later Vasarely changed to colored paperboard prepared by the silk-screen method.

This first alphabet, bright and with few nuances of color, was sufficient for the pictures that we know under the name of *Planetary Folklore* (page 47). Vasarely composed these works in zones of contrasting color. They are the works from which it would be easiest to derive a Vasarely theory of color: simultaneous contrast and zones of similar hue are set off by zones in which the colors interpenetrate. In the last few years Vasarely has still further expanded the idea of the permutational unit. By 1964 he was dealing with a very rich color scale: gray, red, blue, green, yellow, and purple were employed, twelve to fifteen shades of each. In addition, Vasarely resorts to other intermediate shades and mixed colors from time to time. He also employs silver and gold. Each color is broken down into a color scale. The lightest shade is Number 1, the darkest between 12 and 15. By means of these shades, which Vasarely has available in each color for each form and for each background of the plastic unity, he is able to compose works on a large scale even with only two colors. His permutational system gives him almost unlimited possibilities. However, it is a very time-consuming operation to calculate the various plans, have them executed, and correct them. There is more to it than merely realizing a program. Many solutions are rejected. Vasarely's choices, the decisions he arrives at, are therefore basic. Fundamentally, they are hardly different from the activities of painters who find their choices on the palette and try for an optimum solution by means of a system of variations on a theme.[41] Those who feared that Vasarely could produce only results that an electronic brain could supply, results that were completely calculable, should realize that the almost infinite possibilities of variation that the serial system provides call for genuine decision on the part of the artist. In the first place, this cybernetic plastic designing is still carried out in what is virtually a handicraft manner. This has advantages and disadvantages. The advantage is that the personal choice of the artist, his preference for this color or that, remains intact. The disadvantage is that the possibilities of the system are only hinted at. From the artistic point of view, this limitation is certainly decisive. The individual works that Vasarely plans out (it would be 1

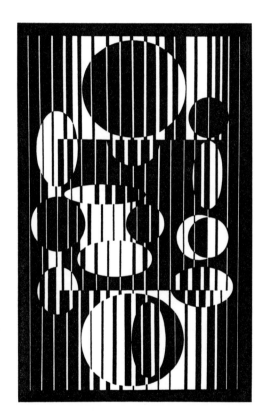

better to say, the works that he represents optically according to calculated tables, and then improves) differ vastly from one another. This makes this cybernetic system, which tests every possibility in advance, a very broad field of realization. Only strongly contrasting solutions, differing from one another in their information content even on the perceptual plane because of differences in aggressiveness, are proposed.[42]

Vasarely, who sketches his works on graph paper, noting the form and color values of the background in one table, and the form and color values of the inner shape in another, has worked out certain semicompulsory, semifree systems. Every picture has a different structure. This would make it necessary to have a kind of musical score on hand for each picture. We should like to point out some of the processes that recur frequently. They never occur altogether systematically. In many works, even the *Chromatic Transitions* that seem so compulsory, we find that Vasarely has made a subsequent correction. There are some works in which it is all but hopeless to try to find this score.

Orion MC (page 47) is a colorful instance of the *Planetary Folklore* that Vasarely would like to spread all over the world. His design is meant to be merely a prototype, which can be repeated at any time without loss of substance. The structural order is not obvious on the level of perception. It irritates us. The interplay of zones that are almost below the optical threshold with others that irritate the eye makes it impossible for us to reach an apperception guided by perception. In point of fact, it does us little good to isolate one zone of the picture and understand it. The simultaneous contrast, the fusion of form and color, do not permit any such process of dealing with the picture by stages. In *Orion MC* we see uniformly distributed zones of color. However, in building up the picture, Vasarely started with a system that begins in the center, in the region of the yellow plastic unity, moves out to the edge of the picture in a kind of spiral movement, and always repeats the same color value at definite intervals.

A further example, not from the *Planetary Folklore* but from the *Chromatic Transitions*, is *IX* (page 55). Here Vasarely works with a silver color: which is used sometimes as inner form and sometimes as background. Yellow, as form or as background, appears in nine different tones. It is light at the periphery of the picture and gets darker and darker toward the center. The change of direction of the inner form (a rhombus, pointing in one of four different directions) gives the surface a strong vibration. *Sirius* too (page 57) is composed in only two colors, one of which, the blue, remains constant. (It is a medium blue, corresponding to something like Number 6 on the color scale. Vasarely prefers medium values for monochrome backgrounds or monochrome central forms.) Here, however, the blue is confined to the inner shape. The backgrounds of the individual plastic unities, composed in gradations of green, are so structured that they create connected geometrical forms. The tendency to combine the chromatic transitions into a Gestalt is clearly visible. Once more we come against Vasarely's old problem: representing a figure or a form on a checkerboard (page 6 bottom). Here he solves the problem of isolating geometrical forms against the background of a uniform structure by means of color.

It is interesting when Vasarely takes the same color as form from dark to light (from the outside inward) and as background from light to dark (from the inside outward) (page 60). Counting diagonally from the corners of the picture, the forms (values 6 and 5) match the backgrounds (values 6 and 5) at the halfway point. The lighter form 5 is on darker background 6, and the darker form 6 on lighter background 5. This produces a diffuse, very pictural effect. At these points the plastic effect, which is based on the color contrast of form and background, disappears; the composition becomes flat.

In many instances these permutation systems are very refined. This is the case for the large works in which Vasarely employs shades of five different colors, or plays four different zones against one another, creating syncopations and inversions of theme. Often he is compelled, in order to retain the differentiation of background and form, to resort to intermediate tones that are not in the 1 to 15

scale. Thus, for example, he will use a value of 5½ for the background of a monochromatic system in which the background has a single hue running through it (page 62). This enables us to experience the form with color value 5 as light, and with color value 6 as dark. If Vasarely were to use a background of value 5 or 6, form and background would coincide at some point.

When one has become familiar with Vasarely's permutational system, it might seem at the outset that it would be in the interests of optical iconography to look for the most complicated solutions—solutions in which the amount of information of colors and forms was as great as possible. There are such cases, but the solutions that can be simply realized predominate. We note that on the one hand Vasarely has launched his creativity on new paths by means of the plastic unities, in an entirely original way that is his alone, while on the other hand the basic problems that Vasarely treats with his plastic alphabet were already present at an early stage. This alone seems to refute the objection that Vasarely replaces sensitivity by a system of calculation. The work that can be reduced to mathematics likewise betrays Vasarely's own personality, his optimistic attitude toward society. It is his accomplishment to have made that personality speak with a new rhetoric. The rhetoric is new; what Vasarely proclaims, a plastic world that can be experienced on the level of perception, affects us with the power of conviction that great aesthetic structural orders can have.

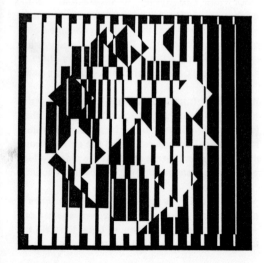

1

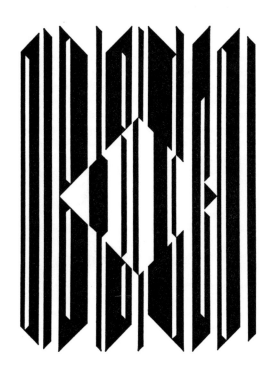

NOTES

[1] The plastic unities vary, as building stones must vary, in order to produce a maximum of forms out of a maximum of standardized elements. The formative qualities of the individual plastic unities vary greatly. The circle with a segment cut off seems to be the unity that brings the most comprehensive forms into being (page 42). Other unities produce illusions of motion (page 67). Still others help to create the contrast of full form against empty (page 46).

[2] He employs Seurat's point, but converts it into an independent molecule.

[3] The perception of relations, the best definition of perception altogether (cf. Maurice Merleau-Ponty, *Phénoménologie de la perception*, Paris, 1945, p. 10), is also at the bottom of Delaunay's system of "simultaneous contrasts." This in turn is based on the researches of Michel-Eugéne Chevreul, who was the decisive theoretician for the Neoimpressionists.

[4] Max Imdahl, in Gustav Vriesen and Max Imdahl *Robert Delaunay: Licht und Farbe*, Cologne, 1967, has shown the decisive importance of Delaunay and the Divisionists for Optical art. He applied the concept of *aporia* to Josef Albers' *Structural Constellations* (foreword to the catalogue *Josef Albers*, Paris, Galerie Denise René, 1968). Also important regarding this problem is the same author's "Probleme der optical art: Delaunay-Mondrian-Vasarely," in *Wallraf-Richartz-Jahrbuch*, XXIX, 1967, 291–308.

[5] In the *Structural Constellations*, in which Albers works with cubes drawn in perspective, the *aporia* is complete. In Vasarely's *Homage to the Hexagon*, in which he uses, alternately, systems of cubes drawn in perspective and axonometrically, we have instead a system that can be interpreted in several ways. Since the sides of the cubes are of different colors, the problems of a plastic quality dictated by the color play a larger part. The question here is not whether a form appears as spatial or two-dimensional, but whether it seems convex or concave: we are confronted by a "shift form." The system sketches alternative hypotheses: the viewer can decide for either. In Albers no decision is possible, since there is no solution.

[6] Additional "impossible figures" in L. S. and R. Penrose, "Impossible Objects: A Special Type of Illusion," in the *British Journal of Psychology*, XLIX, 1958.

[7] Merleau-Ponty (cf. Note 3), p. 26: "Whether a subject has seen Figure 1 five times or 540 times, he will recognize it just about as readily in Figure 2, in which it is 'camouflaged,' and, besides, he will never recognize it there constantly."

[8] Josef Albers, *Interaction of Color*, New Haven and London, 1963, p. 74: "Factual-Actual: In dealing with color relativity or color illusion, it is practical to distinguish factual facts from actual facts." See also Imdahl (Note 4).

[9] Molnar, in *A la recherche d'un langage plastique...pour une science de l'art*, Paris, 1959, tries (in my opinion, too exclusively) to break Vasarely's pictures up into legible individual factors. This method does lead to certain results, but the essential problem, the aggressiveness of the picture, the insult to the viewer on the optical plane, is not brought out. For over and above the single element constituting the picture there is a perception on the level of the Gestalt.

[10] Speaking statistically, "for the most part" means that Vasarely devotes sixty per cent of his activity to works made up of plastic unities. Forty per cent are in the *Black-and-White* domain and free works.

[11] Vasarely is able to make arresting geometrical figures out of a combination of forms in which plastic unities oriented in a definite direction and with a more or less contrasting color pattern constitute in effect colored geological strata (pages 43, 56, 65).

[12] The early graphic works have no interest in color. The Surrealist period of his painting prefers dull earth tones.

[13] Compare what is said in the text on Vasarely's permutational method.

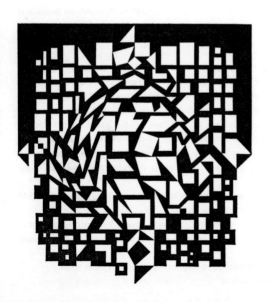

¹⁴ Such a system is also conceivable with a single color, when the form and the background of a plastic unity have different shades of the same color in each case.

¹⁵ The contrary motion of two colors meeting at the same level of intensity produces an unpictural, form-obscuring effect. On the other hand, the meeting of light and dark forms creates the illusion of distance in space (page 65).

¹⁶ The fourth phase, the best-known of the four, comprises Denfert, Belle Ile, and Gordes. It is impossible to separate the single stages of the fourth phase. The works are often proceeding simultaneously, as I saw from looking into Vasarely's notebook. In Vasarely's case, moreover, the fact that he often lets years go by between the sketch for a work and its execution plays a part in questions of dating. This explains the double dating of a number of important works. Vasarely's conviction that an artist must create prototypes, which thereafter can be executed as major works in any number and at any time, is foreshadowed in this method of working.

¹⁷ Up to now, the only reproductions of such early works are to be found in the volume *Vasarely* (translated by Haakon Chevalier), Neuchâtel, 1965.

¹⁸ Ibid., pp. 67f.

¹⁹ A list of Vasarely's most important publications is given in the Bibliography.

²⁰ The family of the Vasarhelyi can be traced back to 1227. A village in Hungary bears the name of the family, which fell into poverty at the beginning of this century.

²¹ An article on Alexander Bortnyik by Ivan Hevesy appeared in the magazine *Magyar Grafika*, Nos 1–2, 1929

²² Letter dated August, 1965.

²³ The points made by Bortnyik in this letter are supplemented by a letter I received in March, 1968, in answer to some questions I had asked him. Its contents will be given here, because in addition to presenting a picture of the art situation in Hungary between the two wars, it contains further details of Vasarely's early phase and his sojourn in the Mühely.

"For lack of space, along with other reasons, I accepted in my private school only students who in my opinion showed definite signs of talent. Vasarely's talent was particularly evident, as could be seen from his quick conception, his inventiveness, his original ideas, and his ability to pursue and expand all sorts of experiments and methods. His fellow students were convinced that his works would win him a position in the first rank of art.

"Between 1910 and 1919 a lively, fresh intellectual atmosphere carried away those of us who were young at that time; it was due to the powerful new artistic phenomena and trends (Avant-garde, Activism, Expressionism, etc.). But this interesting new atmosphere was almost completely smothered after 1919 by the counterrevolution. The time that followed, with the reactionary politics that prevailed in Hungary and the attitude of the official circles of the time, hostile to art and all innovation, was not favorable to the free development of the new trends in art. Official art education was extremely conservative. A few teachers tried to bring new life into teaching but they were removed from the academy after a few years.

"My private school, founded in 1928, was the first step taken toward starting something new, toward reviving the so-called 'constructive' spirit. But at first this was possible only in the field of commercial art (posters, advertising). Something new could be accomplished there, since selling techniques needed new impulses. I continued my school until 1938. Its name was 'Mühely' ('Workshop'), and it was also known as the 'Hungarian Bauhaus.'

"My students reacted very well, especially Vasarely. His powerful imagination showed itself even in the school exercises. I recall one problem, in which the students had to demonstrate their independent comprehension. Vasarely hit upon a solution that was so brilliant in content (idea, invention) and externals (technique, elaboration) that it won the recognition of his colleagues and the invited jury. This was perhaps the first, semipublic success with which Vasarely began his splendid artistic career. He first showed his work publicly at an exhibition in which my school took part. Both visitors and press expressed themselves very favorably about his work.

"In my instruction, the constructive method on a geometrical basis (proportions and rhythm) played a large part. One problem, e.g., was to build up a construction out of different values (dimension and color). The eye was to be trained in working out balance not only in feeling but consciously. In the first phase we worked with combinations in the plane. Later we introduced spatial quality, plastic effects, and perspective.

"Geometry was of course not the final goal, not the sole saving element, but a means on the basis of which it would be possible to work with freer real forms. It should not be forgotten that we had to use psychological as well as physical

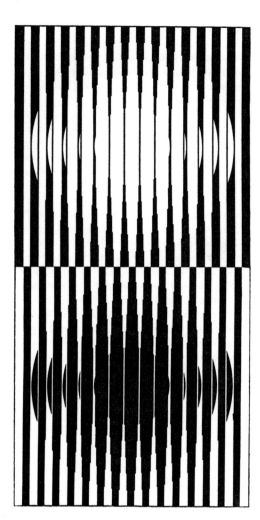

methods for the so-called 'painting for use.' Letters too had their role; introducing them into the construction was not merely an inevitable, necessarily bad, supplementary factor (in posters, book jackets, etc.), but an essential part of the composition.

"The students had to learn something that they could make a living from. The demand for 'free' works of art, paintings and so forth, was very small at that time, and especially so for 'modern' works: there were practically none. I am referring to the period from 1919 to World War II. Today conditions in art are quite different, much more favorable.

"You ask whether we knew of Malevich, Suprematism, Constructivism. Of course. I had lived in Weimar for several years, and had become acquainted there with the Bauhaus, its teachers and students, with Lissitzky, Doesburg, the Stijl group, Schwitters. We discussed the various conceptions and trends. On many things we were in agreement; on many we had opposite opinions. Prior to that, while still in Vienna, I had practiced a kind of abstraction (visual architecture) for some time, and put out a publication on it with eight color reproductions.

"Incidentally, some of the work I did in 1920–23, now in private collections and museums, has recently been shown in West Germany: in the Frankfurter Kunstverein (Nov. 19, 1966, to Jan. 8, 1967), in the exhibition of 'Constructive Painting, 1915–1930,' and in the Berlin 'East European Avant-garde, 1910–1930' show in the Akademie der Künste (Oct.–Nov. 1967). Some of my works are reproduced in the catalogues.

"I hope that these particulars have provided answers to your questions. Even though they may not be exhaustive. Don't forget that at a distance of almost forty years it is only the over-all impression that prevails, while many details, which possibly might interest you more, have faded."

[24] Vasarely tells us that it was not until 1947 that he came to know the work of Freundlich, who lived in Paris at that time.

[25] Cf. such titles as *Metagalaxy, Cassiopeia, Vega*. Vasarely gave a systematic exposition of the contents of the pictures in 1956. Cf. Note 36.

[26] They try to reproduce the various surfaces of material with photographic precision. This is the decisive difference from the Bauhaus, where the effort was to use the tactile interaction with materials to attain new design forms, productive and not reproductive in nature.

[27] The contrasts of the objects chosen by Vasarely also have a Dadaist attraction and a charm reminiscent of Chirico.

[28] "Shift forms" play a particularly important role in the *Homage to the Hexagon*. Even before that, they are fundamental in the work of the *Black-and-White* period. And cf. Note 5.

[29] In Vasarely's writings the attack against art that assumes knowledge of art history or aesthetics in the viewer is unmistakable.

[30] This was the first show organized by Denise René.

[31] Vasarely gives the following definition of this work: "Malevich's square, the beginning and the end of the plastic adventure in the plane, goes beyond its destiny: the lozenge, another expression of the square, is in fact square + space + movement + time." *Vasarely*, p. 32.

[32] "Paranoiac-critical activity" is defined as follows by Dali: "Spontaneous method of irrational knowledge, based on an interpretative-critical association of illusory phenomena." The method serves to read an object (not merely an amorphous object, such as a cloud, but any image quite real in appearance) in a new way, by alienating it.

[33] Vasarely used the concept of *cinétisme* ("kinetism") as early as 1954. At that time he did not know Gabo and Pevsner's *Kinetic Rhythms* (in the *Realistic Manifesto*, Moscow, 1920) nor Gabo's *Kinetic Plastics*, of the same year. Vasarely introduced the concept with an entirely new meaning: Kinetics is located on the level of perception. It is an aesthetic element that is independent of movement.

In the Lumière et Mouvement ("Light and Motion") show (Paris, Musée d'Art Moderne, 1967) Vasarely exhibited four mechanically operated works. For this show he went back to his *Transparencies* (1955–1958). These consist of two superposed sheets which the viewer can shift with reference to one another. In the large models executed for the exhibition, Vasarely used mechanical motion, instead of having the viewer himself move the sheets. This motion imitates a previous experience brought about by the viewer himself.

[34] *Vasarely*, p. 44. Vasarely introduced film into his work as the vehicle of kinetics. He has been working for years on a film that breaks his work down into motion.

[35] The interpretability of flecks of color is discussed in Leonardo's *Treatise on Painting*.

[36] Arcueil, May 1956. Reprinted in French in *Vasarely*, p. 57.

[37] Vasarely's writings go into these questions at length. He has sketched the main idea as follows: "Art today is on the way to generous forms, reproducible at will; tomorrow's art will be common treasure or it will not exist." *Notes pour un manifeste*, Paris, 1955. In the *Plan einer Fondation Vasarely* he elucidates the sociological and aesthetic consequences of this new attitude toward art. (Cf. catalogue to the Vasarely show, Galerie Hans Mayer, Esslingen, 1967.)

[38] *Vasarely*, p. 14.

[39] Vasarely has on occasions drawn distinctions in his attitude on this question. In a talk before Sigma in Bordeaux, 1967, he distinguishes between "reproduction" and "re-creation."

[40] The distance between image and hand, fundamental to the plastic unity, recalls Matisse's late collages. Matisse, confined to his bed in 1952, executed them with the help of assistants. He cut the forms out of colored paper with scissors and gave directions as to how they should appear in the composition. At the time, Vasarely was fascinated to learn of this way of working.

[41] This becomes clear to us in Picasso's later work. Picasso abandons his earlier procedure, which consisted of preparing a large synthetic pictorial image in a number of works and preliminary sketches. He no longer decides in favor of a *single* work. He puts down his good and bad moments. This provocative juxtaposition of all the solutions is interesting. Picasso prefers to the one solution the accumulation of the largest possible mass of potential solutions. He sets in contrast to the picture as teleological end product, the picture as tension-free, instantaneous realization.

[42] I raised this question in a talk at the Galerie Brusberg, Hanover, in November, 1967. I was particularly interested in Vasarely's proposal that other artists might employ his plastic unities: "...If we think that Vasarely is the first of an endless series of artists who will elucidate this theory as their theory of salvation, and the salvation of art, it is evident that those artists, even if they have no intention of differentiating themselves from Vasarely or from one another in terms of some kind of romantic quest for artistic originality, will have to determine their form and color units anew in each case, and always in the direction of enriching the information the units contain. As in art up to the present, the complication of methods and alphabets will be diffracted in a thousand temperaments. Sooner or later the complication, even if based on mathematical and serial calculations, will become so great that the cool, mathematical aspect that Vasarely has introduced will disappear, or be recorded as a historically comprehensible contribution. The more complicated the formal relations become the nearer will these works come to free design."

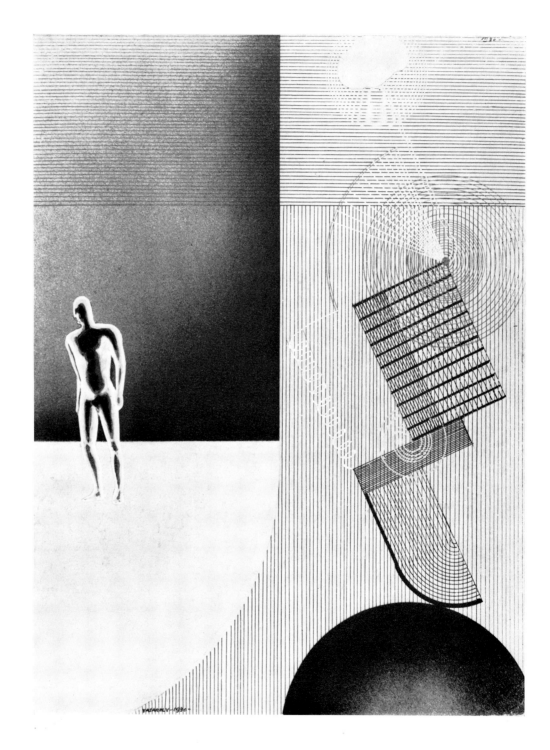

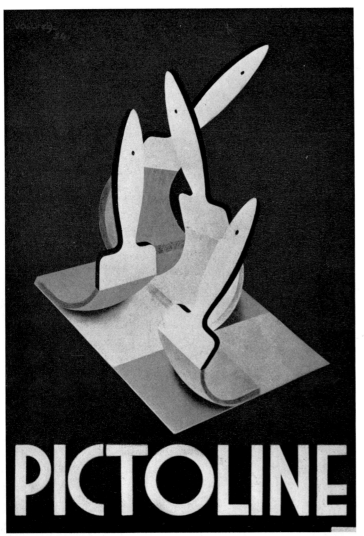

PICTOLINE

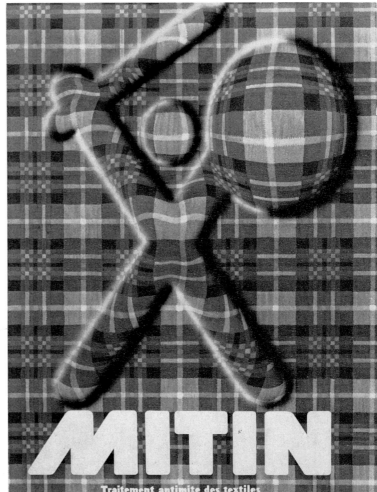

MITIN

Traitement antimite des textiles

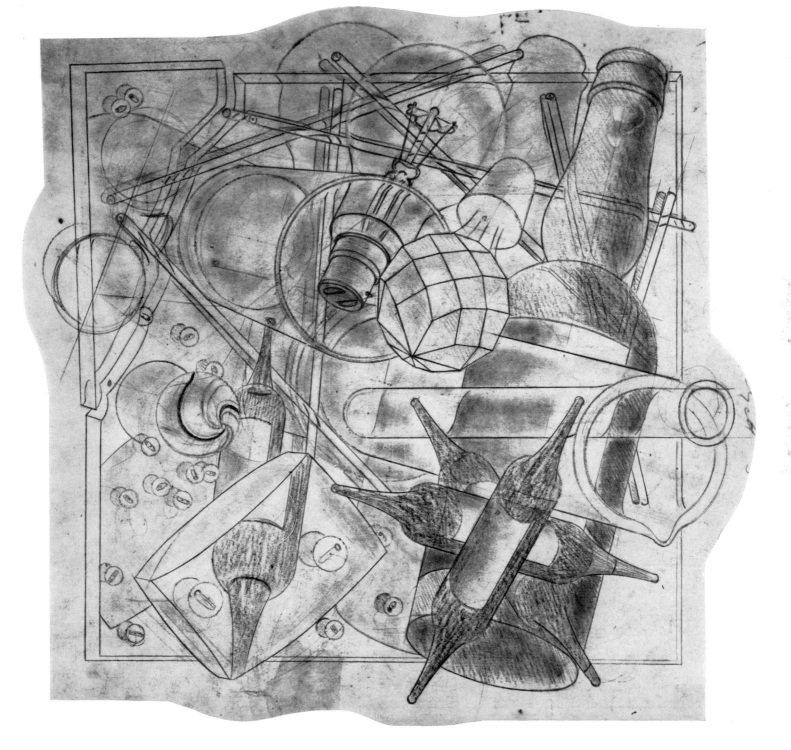

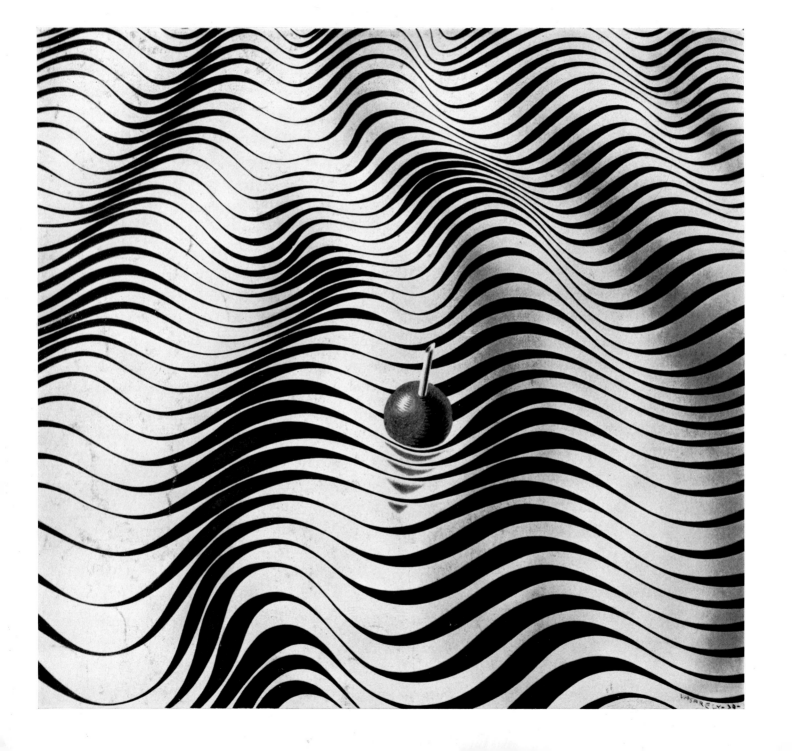

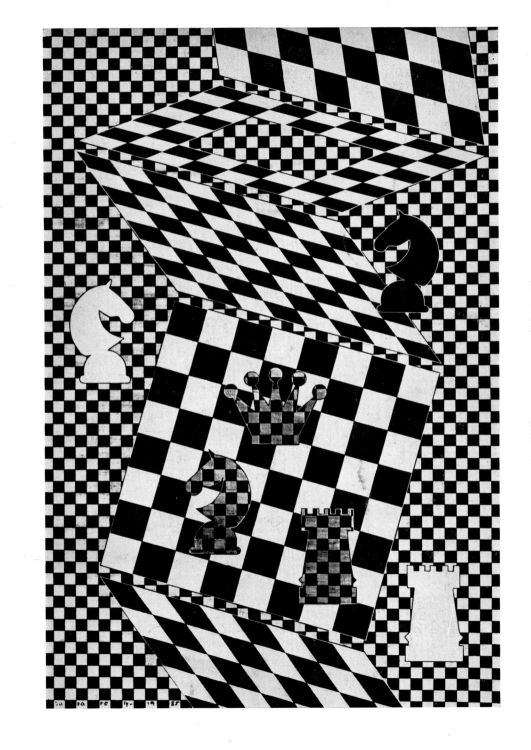

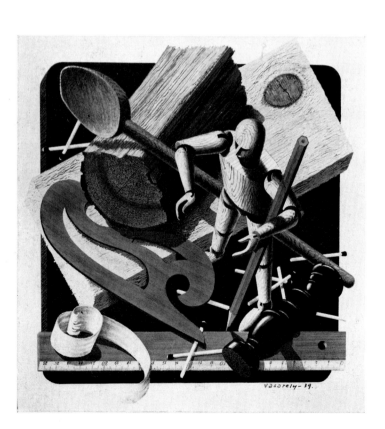
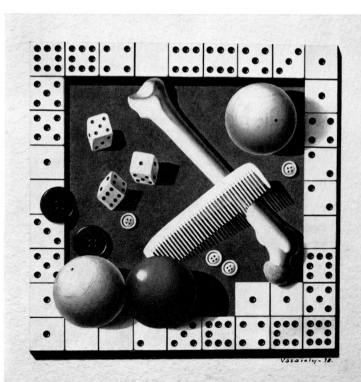

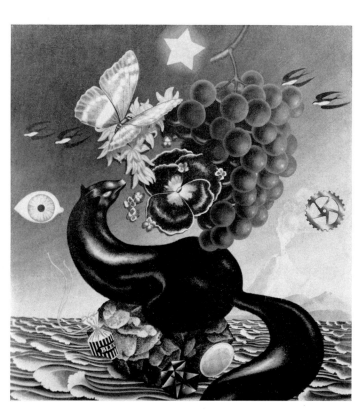

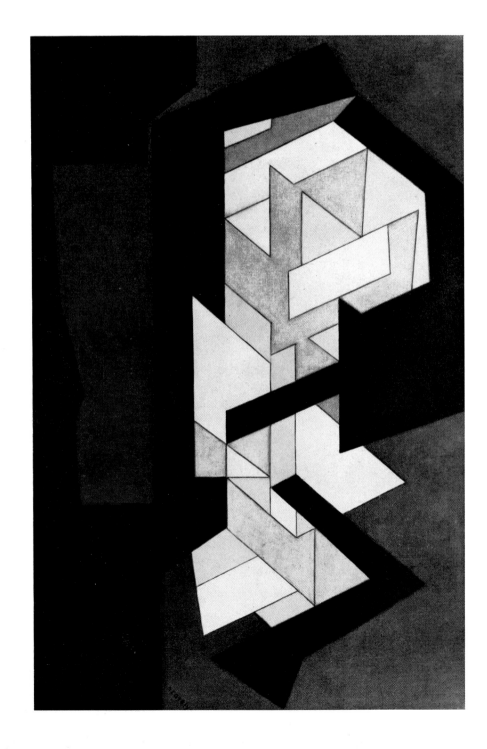

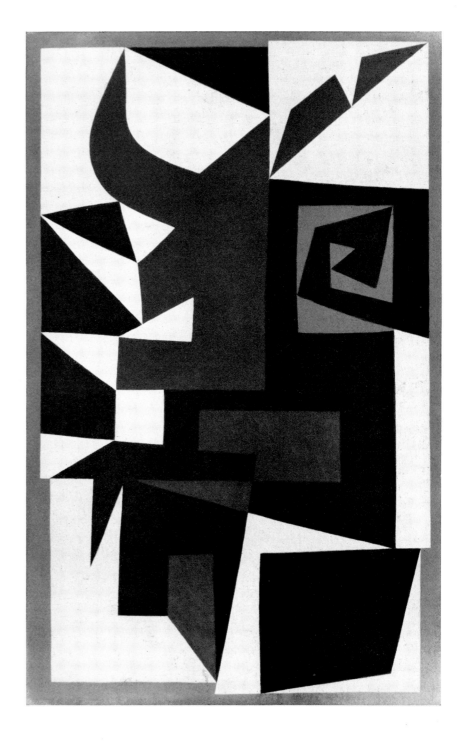

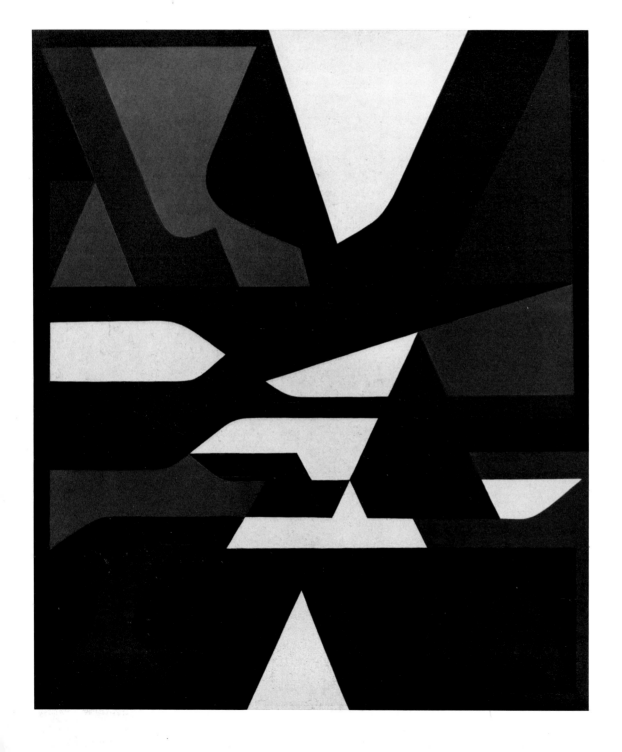

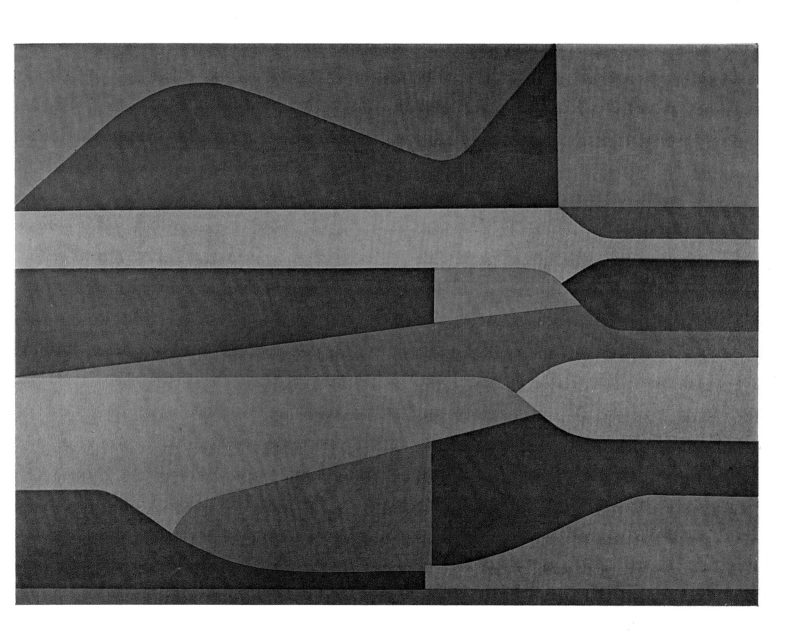

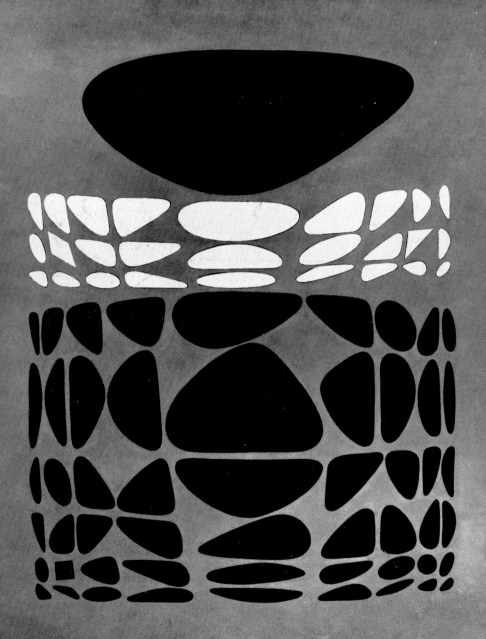

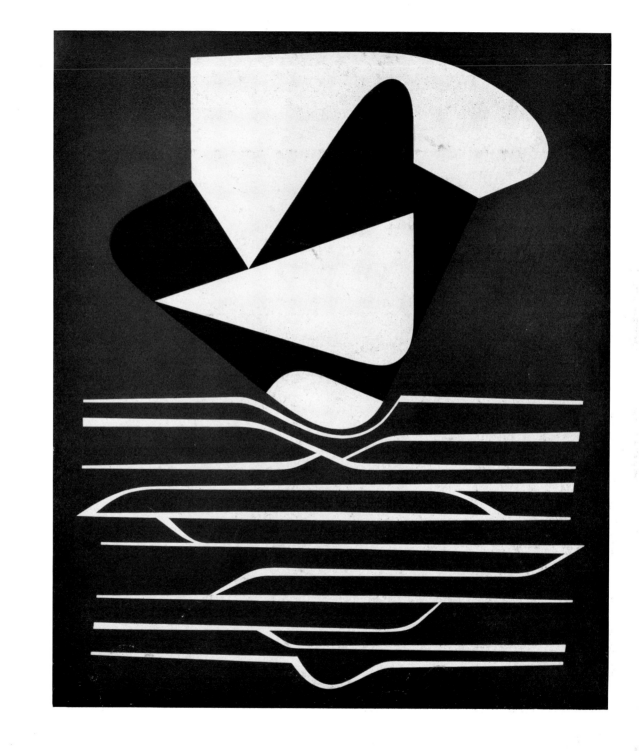

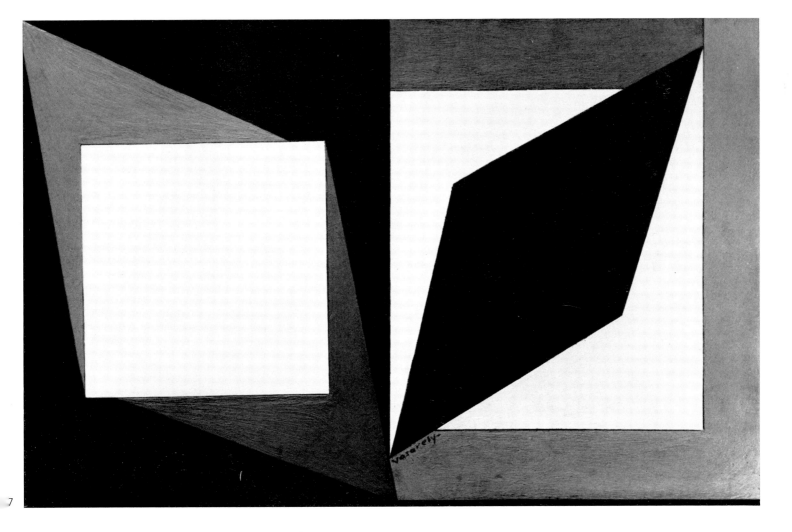

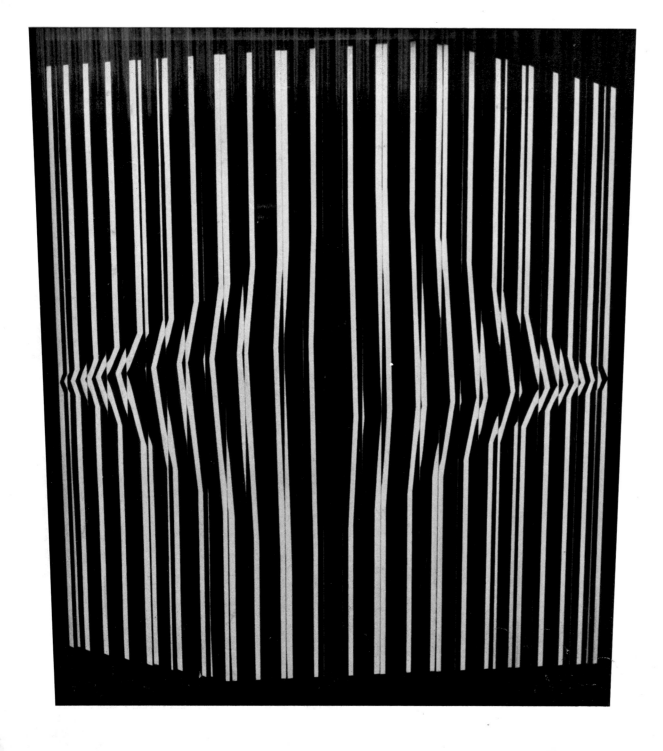

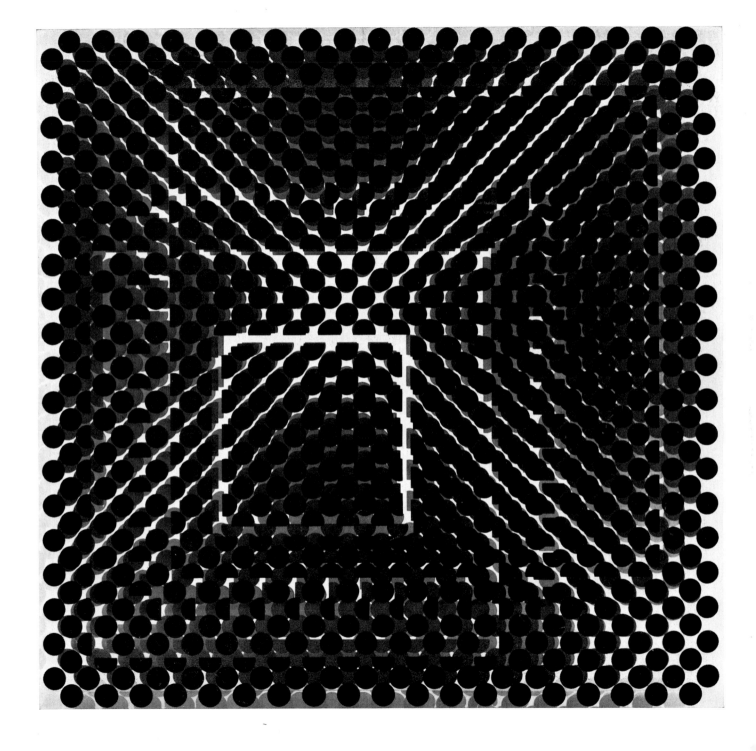

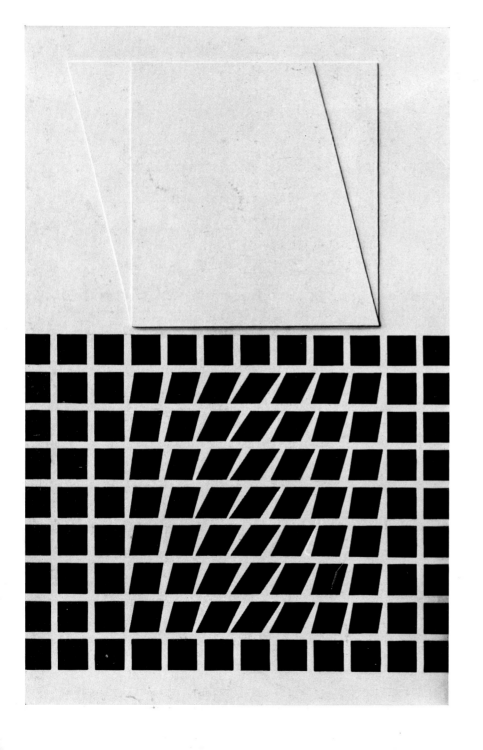

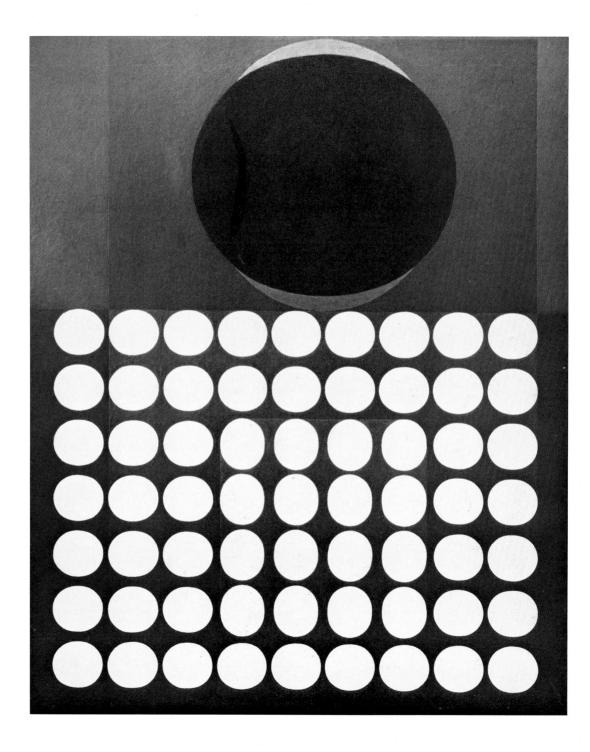

1

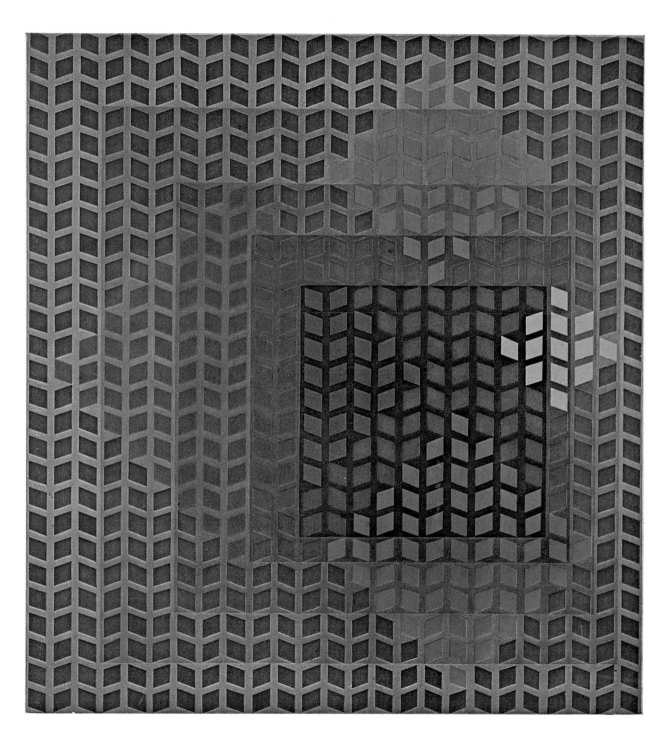

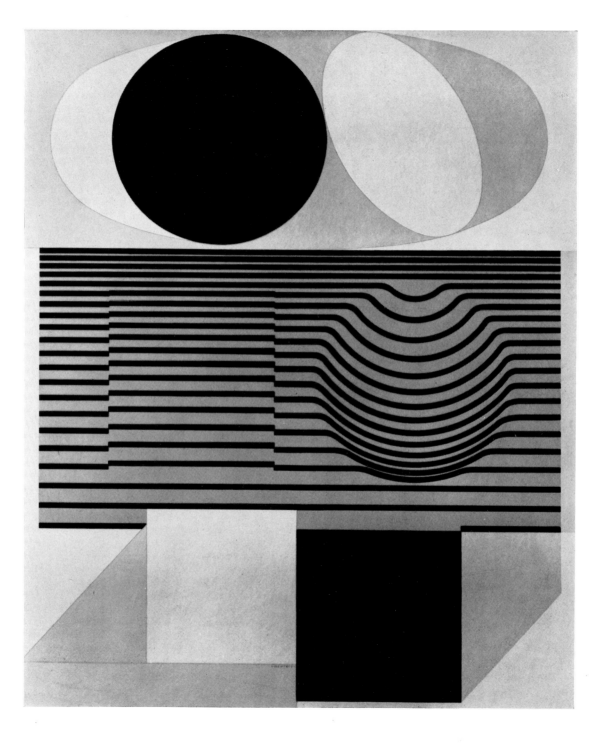

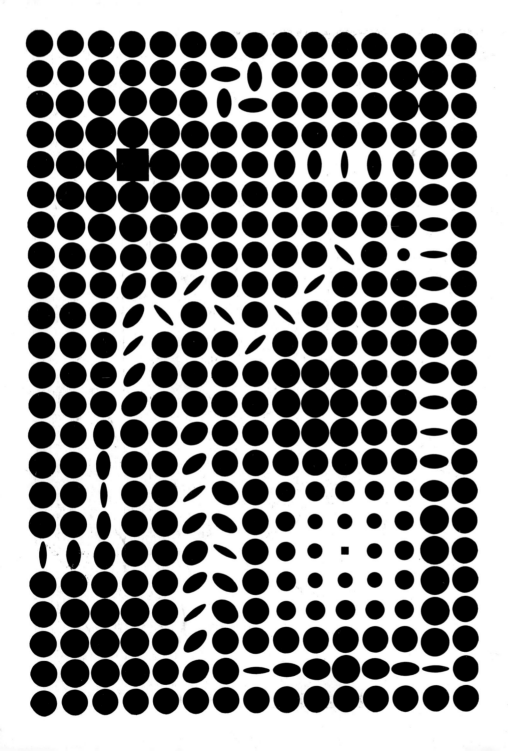

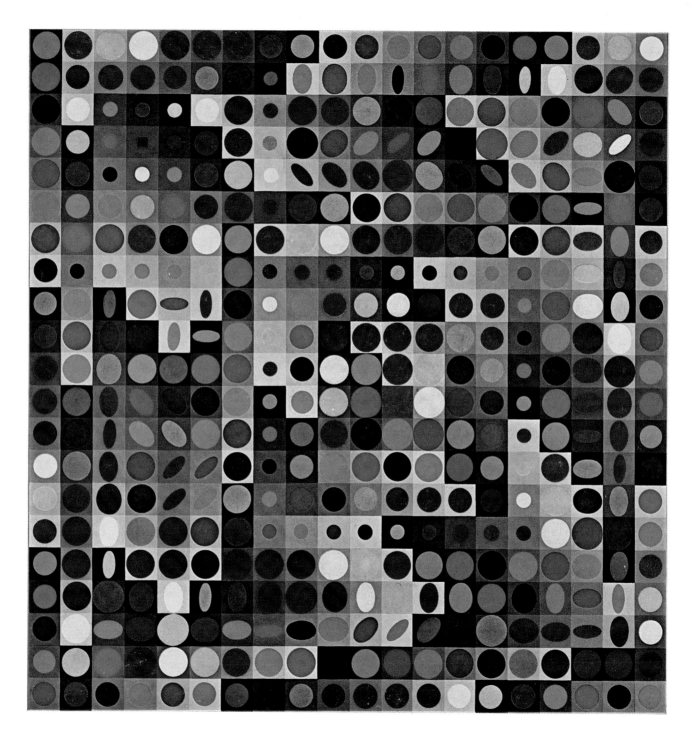

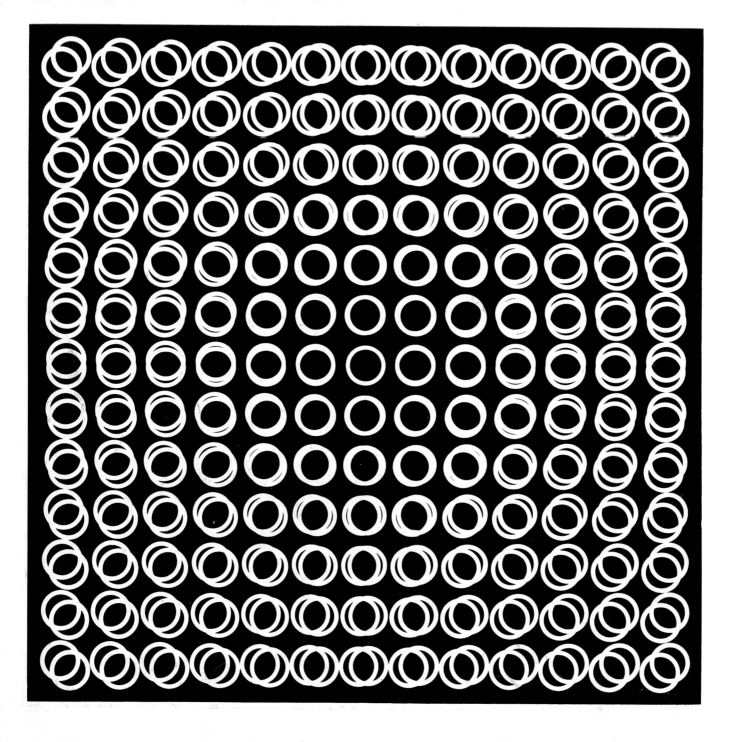

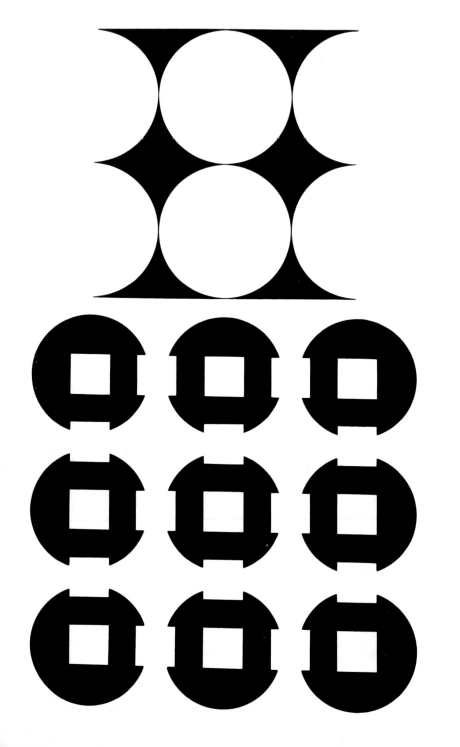

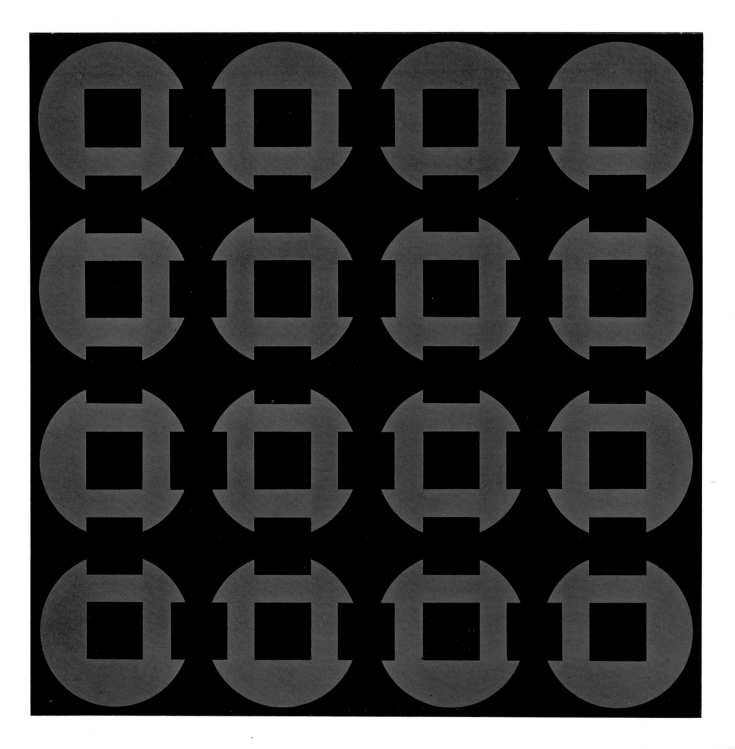

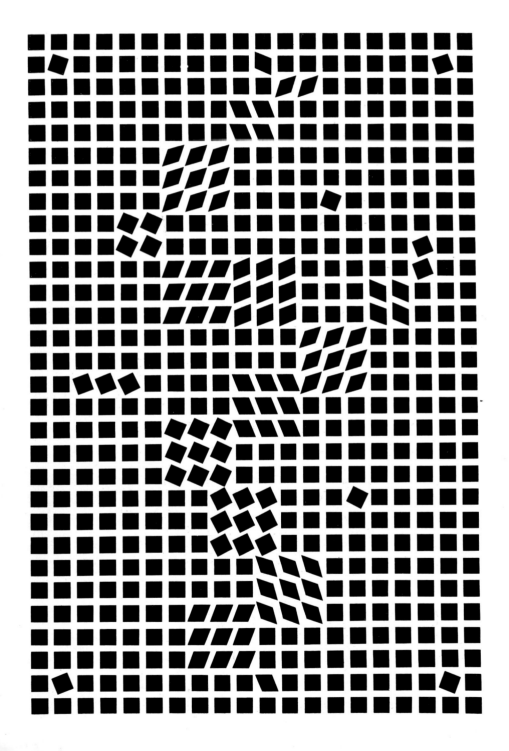

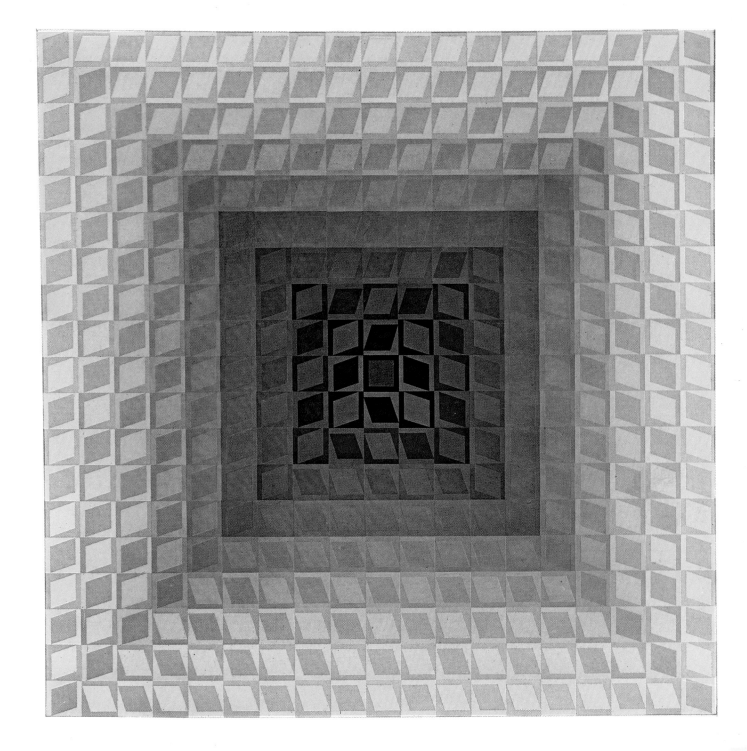

5

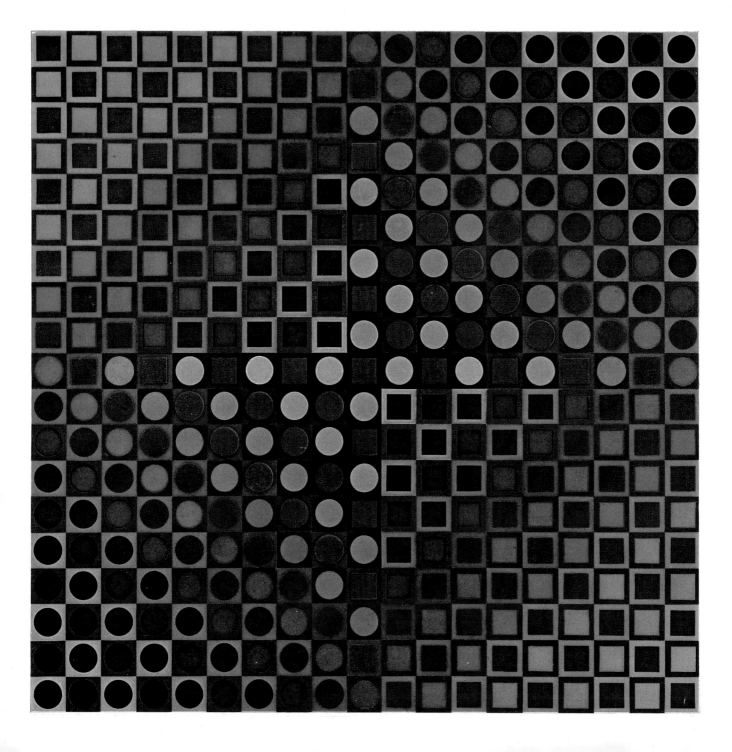

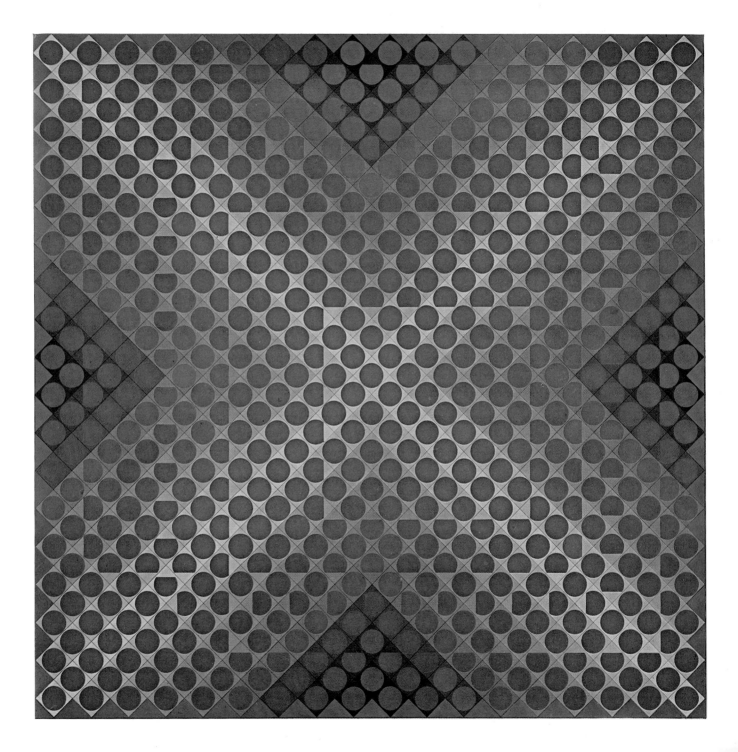

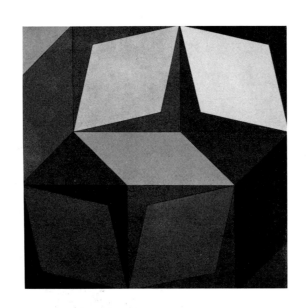

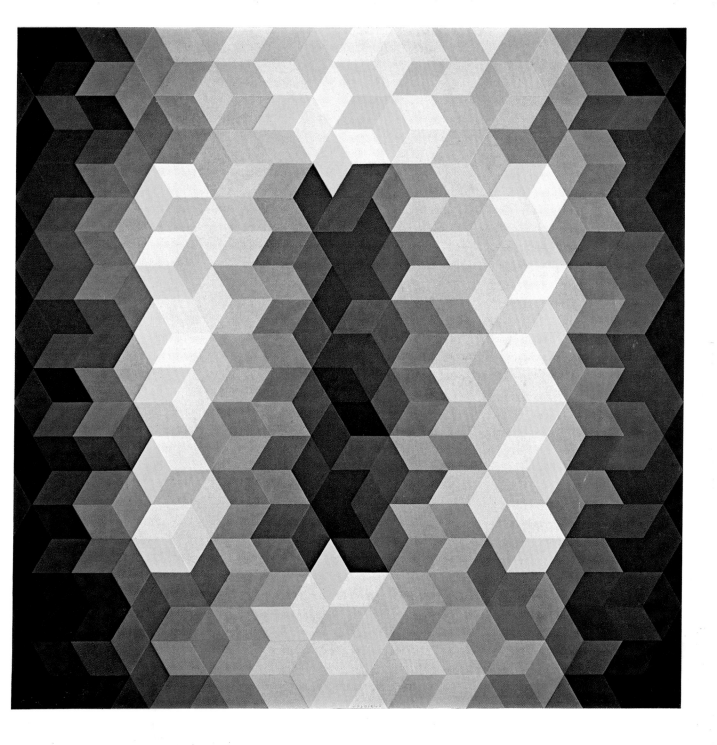

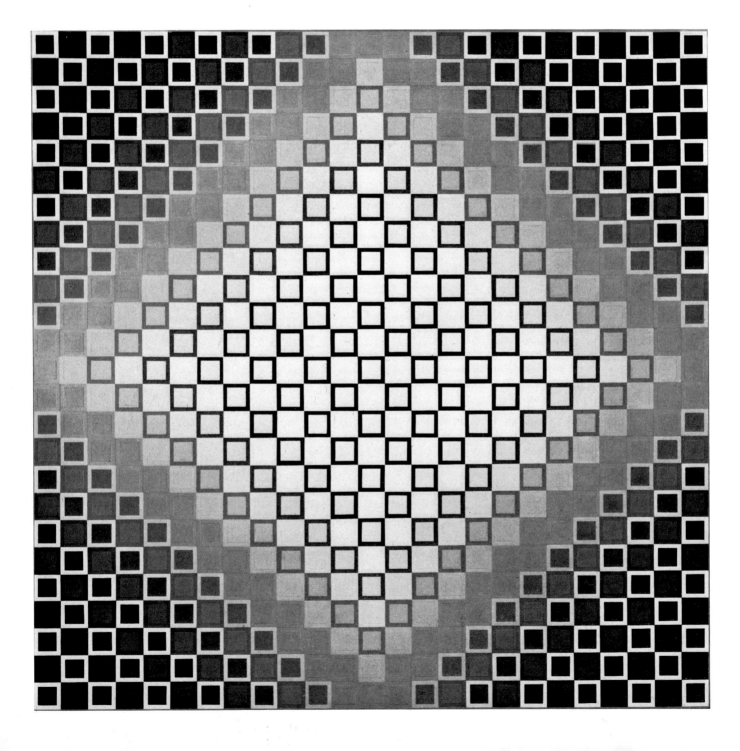

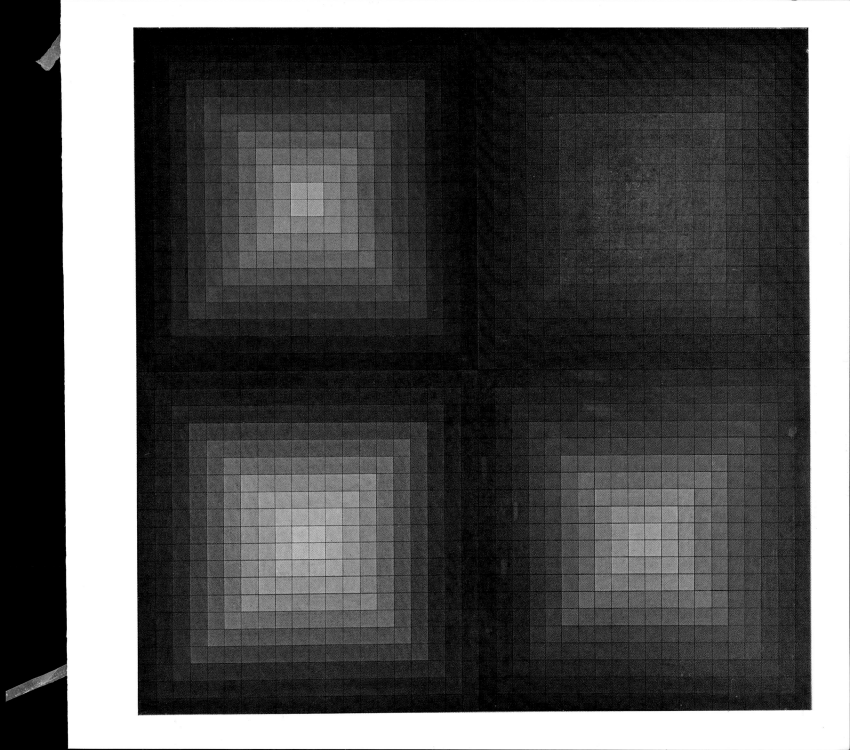

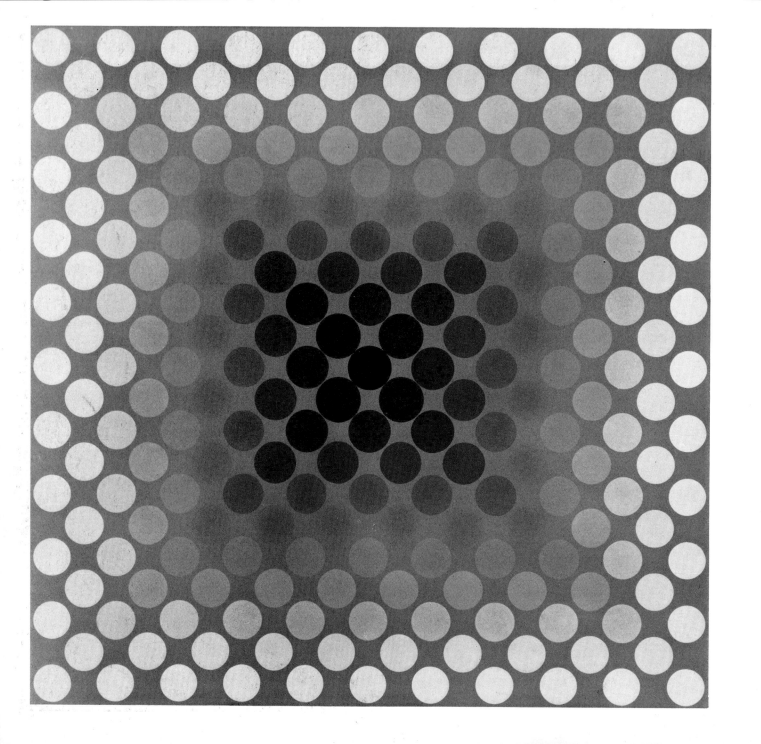

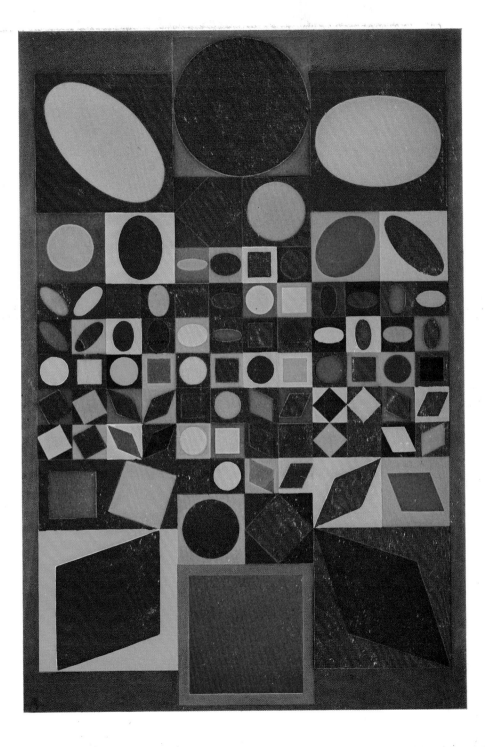

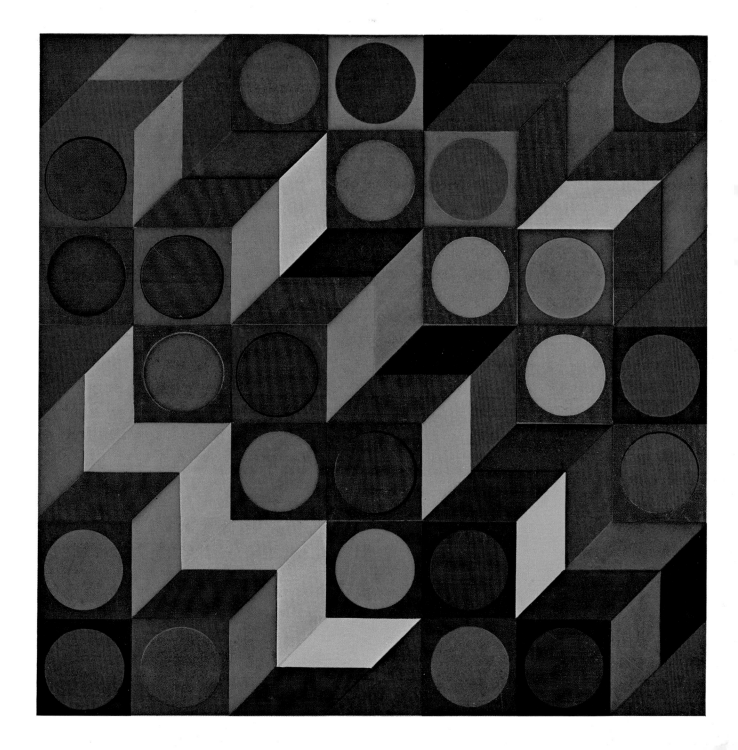

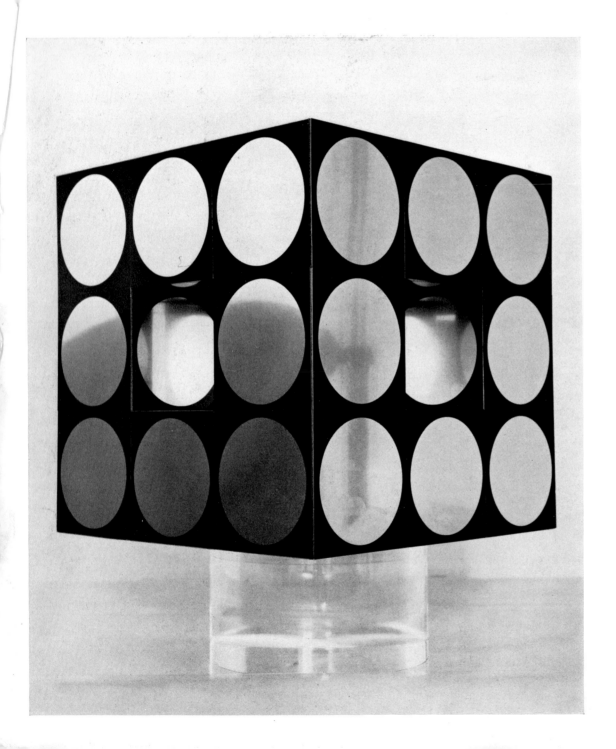

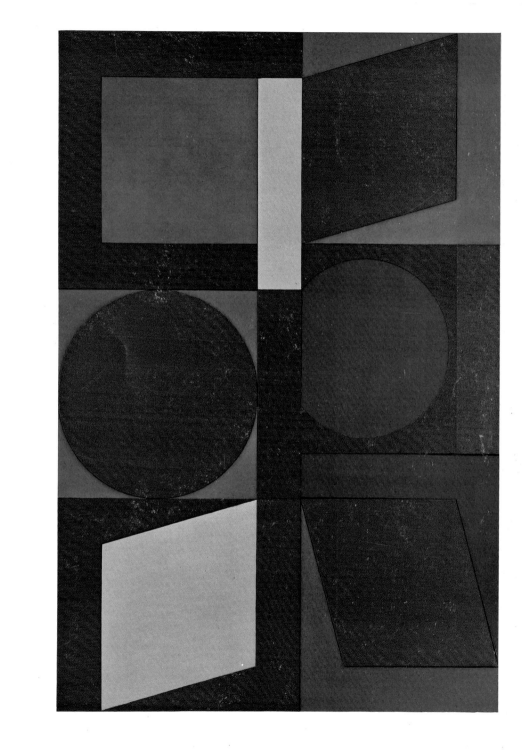

List of Plates

40 *Likka*, 1956–59, relief and oil, 93 × 61 cm., 36¾ × 24 in.

41 *Laïka II*, 1957–59, oil and cardboard relief, 162 × 130 cm., 63¾ × 51 in.

42 *Cassiopeia*, 1957, oil, 195 × 130 cm., 76¾ × 51 in.

43 *Hoonan-C*, 1956–63, tempera, 63 × 60 cm., 24¾ × 23¾ in.

44 *Birth*, 1952, drawing, 30 × 60 cm., 11¾ × 23¾ in.

45 *Ondho*, 1960, oil, 220 × 180 cm., 86¾ × 70¾ in.

46 *Betelgeuse*, 1957, oil, 195 × 130 cm., 76¾ × 51 in.

47 *Orion MC*, 1963, oil, 170 × 160 cm., 66¾ × 63 in.

49 *Blue*, 1964–67, relief and tempera, 75 × 75 cm., 29½ × 29½ in.

50 *TUZ-3*, 1966, tempera, 84 × 84 cm., 33 × 33 in.

51 *TUZ*, 1965, tempera, 84 × 84 cm., 33 × 33 in.

52 *Canopus*, 1959, oil, 195 × 114 cm., 76¾ × 44¾ in.

53 *Procion-kek*, 1966, tempera, 84 × 84 cm., 33 × 33 in.

54 *Tlinko*, 1955, oil, 195 × 130 cm., 76¾ × 51 in.

55 *IX*, 1966, tempera, 84 × 84 cm., 33 × 33 in.

56 *Boglar-III*, 1966, tempera, 76 × 76 cm., 29⁷/₈ × 29⁷/₈ in.

57 *Sirius*, 1965–66, tempera 175 × 175 cm., 68¾ × 68¾ in.

58 *Fragment*, 1966, tempera.

59 *Meh*, 1967, tempera, 180 × 180 cm., 70¾ × 70¾ in.

60 *Boglar-7*, 1967, tempera, 50 × 50 cm., 19¾ × 19¾ in.

61 *Arcturus II*, 1964–65, tempera, 160 × 160 cm., 63 × 63 in.

62 *Goyo-SZ*, 1966, tempera, 75 × 75 cm., 29½ × 29½ in.

63 *Planetary Folklore*, 1964, oil, 195 × 114 cm., 76¾ × 44¾ in.

64 Plastic unity.

65 *Zett-Z*, 1965, tempera 160 × 160 cm., 63 × 63 in.

66 Plastic unities.

67 *Illik*, 1965, tempera, 80 × 80 cm., 31½ × 31½ in.

68 *Vonal-1*, 1968, tempera, 160 × 160 cm., 63 × 63 in.

69 *Hatos II*, 1966, tempera, 22 × 22 cm., 8¾ × 8¾ in.

70 *UR*, 1966, metal "multiple," 18 × 18 × 18 cm., 7 × 7 × 7 in.

71 *Kalota-MC*, 1967, tempera, 150 × 100 cm., 58½ × 39¼ in.

Biography

1908	Vasarely is born on April 9 in Pécs, Hungary.
1925	Finishes his secondary education.
1927	Studies at the Podolini-Volkmann Academy.
1929	Studies with Alexander Bortnyik at the Mühely, the so-called Budapest Bauhaus.
1930	Moves to Paris.
1930–1940	Works as a commercial artist, during 1931–35 for Havas, Draeger, and Devambez.
1944	Devotes himself exclusively to painting. Is given his first exhibition by Denise René.
1947	Decides to concentrate on constructive-geometric abstraction. Belle Isle period.
1948	Gordes period.
1951	Denfert period.
1955	"Manifeste jaune." Kinetic period. Architectural commissions, tapestries. Is involved in a film about his work. Serigraphs. Gold medal of the Triennale, Milan.
1961	Leaves Arcueil and moves to Annet-sur-Marne.
1964	Guggenheim Prize, New York.
1965	First prize at the Sixth International Graphics Exhibition in Ljubljana. First prize at the Eighth Biennale in São Paulo.
1966	Is made honorary citizen of New Orleans. Prize at the First International Biennale of Graphic Works in Cracow.
1967	Prize for painting from the Carnegie Institute, Museum of Modern Art, Pittsburgh.

Bibliography

Until now, no monograph on Vasarely has been available.
The most comprehensive book, with texts and dummy prepared by the artist himself, is *Vasarely*, published by Editions du Griffon, Neuchâtel, 1965; edited and with an introduction by Marcel Joray; translated into English by Haakon Chevalier.

Belloli, Carlo. "Vasarely and the Integration of the Arts," *Metro*, no. 4/5, May, 1962.
Claus, Jürgen. "Victor Vasarely: Die bunte Stadt," *Kunst heute*, Rowohlts Enzyklopädie, Hamburg, 1965.
Clay, Jean. "La Géométrie mouvante de Vasarely," *Réalités*, no. 230, Paris, 1965.
Dewasne, Jean. *Vasarely*, Paris, 1952.
Faré, Michel. Introduction to the catalogue of the exhibition at the Pavillon de Marsan, Paris, 1963.
Habasque, Guy. "Vasarely et la plastique cinétique," *Quadrum*, no. 3, Brussels, 1957.
Hill, Anthony (ed.). *D.A.T.A.: Directions in Art Theory and Aesthetics*, London, 1968.
Imdahl, Max. "Probleme der optical-art: Delaunay-Mondrian-Vasarely," *Wallraf-Richartz-Jahrbuch* vol. XXIX, pp. 291–308, Cologne, 1967.
Lier, Henri van. *Le Nouvel Age*, Tournai, 1962.
Lier, Henri van. "Vasarely prisme du nouvel âge," *Quadrum*, no. 27, Brussels, 1966.
Lynton, Norbert. "Vasarely," *Art International*, vol. V, no. 9, 1961.
Miller, Donald. "Vasarely," *Art International*, vol. XIII, no. 10, 1969.
Moles, Abraham A. "Vasarely and the Triumph of Structuralism," *Form* (Cambridge), March, 1968.
Moles, Abraham A. "Victor Vasarely," in the catalogue of the Seventh International Graphics Exhibition, Ljubljana, 1967.
Molnar, François. *A la Recherche d'un langage plastique pour une science de l'art*, Paris, 1959.
Panderma, no. 6, 1964. Entire issue devoted to Vasarely.
Popper, Frank. *Naissance de l'art cinétique*, Paris, 1967.
Rose, Barbara. "New York Letter," *Art International*, vol. VIII, no. 6, 1964. Review of an exhibition at the Pace Gallery, New York.
Spies, Werner. "op art und Kinetik," introduction to the catalogue of *documenta IV*, Kassel, 1968.
Spies, Werner. "Picasso-Vasarely," *Brusberg-Berichte*, no. 2, Hanover, 1968.
Vasarely, Victor. Statements by the artist on the evolution of painting, in *Art International*, vol. III, no. 8, 1959.

All the photographs for the black-and-white and color plates were taken by Anne Marie Desailly, Paris, with the exception of that for page 60, which was provided by André Morain, Paris.